LOST
PORTLAND
OREGON

VAL C. BALLESTREM

THE
History
PRESS

Published by The History Press
Charleston, SC
www.historypress.com

Front cover: Oregon Historical Society Research Library.
Back cover: Architectural Heritage Center Library; *inset*: Architectural Heritage Center Library.

First published 2018

Manufactured in the United States

ISBN 9781467139533

Library of Congress Control Number: 2018952864

*For Holli. Words cannot express how grateful I am
for your never-ending encouragement and support of my work.*

CONTENTS

Preface 9
Acknowledgements 11

CHAPTER 1
1895–1917: EXPANSION AND COLLAPSE 13

Portland Cathedral 14
Central School 16
Industrial Fair Exposition Building 17
Multnomah County Courthouse 18
Marquam Building 20
Portland Library 23
St. Helens Hall 24
Levi White House 26
Taylor Street Methodist Church 28

CHAPTER 2
1922–1929: THE BLAZING 1920s 31

Washington High School 32
Charles and Hedwig Smith House 34
Beth Israel Synagogue 36
Henry Failing House 38

Contents

Elks Lodge 40
Joseph and Augusta Dolph House 42
Portland High School 43
Masonic Temple 46
Women of Woodcraft Lodge 48
Charles and Sallie Forbes House 50

Chapter 3
1930–1949: Modernizing the City 52

Harrison Street School 53
Portland Chamber of Commerce 54
Washington Building 56
Henry and Emma Corbett House 58
Hibernian Building 59
Stephens School 62
Front Avenue 64
Witch Hazel Building 67
Worcester Block 69
Jacobs Family Houses 72
Hill Military Academy 73
Kamm Block 75
Nahum and Martha King House 77

Chapter 4
1950–1967: Displacement and Destruction 80

Oregonian Tower 81
Richard and Minnie Knapp House 83
Portland Hotel 85
Ainsworth Block 88
McMillen's Addition and Lower Albina 90
Julius and Bertha Loewenberg House 93
Perkins Hotel 95
Forestry Building 97
South Auditorium Urban Renewal Area and Interstate 405 99
Portland Academy 103
Ladd Block 104
Abington Building 107

CONTENTS

CHAPTER 5
1969–2017: LOSS IN THE AGE OF PRESERVATION **110**

 Public Market 111
 St. Mary's Academy 113
 Selling-Hirsch Building 115
 St. Vincent's Hospital 117
 Jeanne d'Arc 119
 Congress Hotel 121
 Ahavai Sholom Synagogue 123
 Lenox Hotel 125
 Corbett and Goodnough Buildings 127
 Portland Gas and Coke Company Building 130
 Holman Family House 132
 Ancient Order of United Workmen Temple 134

Notes 137
Bibliography 143
Index 147
About the Author 159

PREFACE

When I first considered writing a book on "Lost Portland," I ran through a bunch of concepts as to what that meant. Lost what? People? Ideas? Longtime businesses? Sure, there are plenty of great examples of "lost" among all of these threads, but what about buildings or even neighborhoods? Portland has seen more than its fair share of such places lost, whether by design, neglect or accident. Many of these places have been gone so long that few people remember that they ever existed.

Thousands of structures have come and gone during the 150-plus years since Portland incorporated as a city. In developing the concept for this book, I decided to focus on aspects of Portland's built environment that, at least at the time of construction, were considered significant additions to the city's architectural landscape. This includes major commercial buildings, schools, houses of worship and a selection of architecturally interesting and historic houses, along with streetscapes and neighborhoods.

Through brief stories, I hope to exemplify how the city has physically changed over time and how old buildings are often held as a hindrance to progress. Temporary buildings and structures are not part of this story. Although lost aspects of the city, such as wartime housing, are replete with social, cultural and historical significance, they deserve a more thorough treatment than is possible in a book of this nature. Because the central city has always dominated the built landscape of Portland, most of the stories told herein take place on the west side of the Willamette River. For the east

side of town, my goal was to include losses that represented major events, attitudes or changes in the city as a whole.

In deciding how to organize this collection of building stories, I took the advice of a colleague and friend who suggested I tell the stories in chronological order, by date of loss, rather than dividing them up thematically. The results, however arbitrary and imperfect, are five chapters that I feel are representative of the waves of architectural loss in Portland. In order to put these lost places in context with the Portland of the twenty-first century, I have used current street names and designations so that readers can better imagine what was once there.

As a firm believer in building conservation, I hope that this book prompts the reader to consider what we are losing today that should possibly be saved and, certainly, that should not be forgotten. As has happened throughout the United States, in Portland, we regularly and willfully destroy the hard work of our forebears. Is architectural loss a necessary part of progress? I would argue that it is a less than creative approach; it is neither socially, culturally or environmentally sustainable to continue erasing our physical past in the name of the future.

With that said, the loss of a building is not necessarily a bad thing. Some famous architectural losses in Portland have ultimately led to very good things. The beloved Portland Hotel was demolished more than sixty-five years ago and few Portlanders in 2018 ever stepped through its doors. However, with Pioneer Courthouse Square (built on the same property), it is safe to say the city eventually benefited from the loss of the hotel. At the same time, readers will note the significant number of losses in this book that resulted in not-so-positive outcomes. In 2018, is an eighty-plus-year-old surface parking lot in the heart of downtown really the best we can do?

This book is not a lament, although there are some very lamentable losses. I hope this book helps to broaden our understanding of how a city changes and how important—or at least interesting—aspects of the past can get lost in the shuffle. As I write, new losses are taking place around the city while residents, special interests and officials struggle over the outcome. We can only hope that the new building causing a loss today will be the architectural landmark of tomorrow.

ACKNOWLEDGEMENTS

I n the summer of 2017, I heard that The History Press was looking for someone to write about lost Portland architecture, and the idea struck an immediate chord. For years, I had envisioned writing a book about Portland's past, and for once, the timing felt right. I had just curated an exhibit at the Architectural Heritage Center on essentially the same subject, so the concept was fresh in my mind. With encouragement from my wife and colleagues, I embarked on this fun and challenging journey.

The images in this book offer only a glimpse into some amazing Portland-area collections. The library and archives at the Architectural Heritage Center include a wonderful postcard collection along with the photography of George McMath and others. Access to this collection was key to making this book happen. I am forever grateful to Norm Gholston for sharing images from his private collection that include rarely seen views of the city. Thank you to Matt Cowen at the Oregon Historical Society for making its Minor White photographs from the late 1930s and early '40s available, and to Ken Hawkins for his insight and expertise into this collection. Tom Robinson, the Portland Archives and Records Center, Oregon Health and Science University Historical Collections and Archives, and Ed Teague at the University of Oregon Libraries also provided images, as did my colleague at the AHC, Doug Magedanz. Thank you all for helping to make this book possible.

I am also grateful to the many friends and colleagues who provided advice and support for this project, including Morgen Young, Amy Platt, Maija

Anderson and the gang from the Ben Holladay Society, including Alexander, Dan, John and Tim. Lastly, I should thank Clio the cat for her constant attention while I spent countless hours writing and researching.

1

1895–1917

Expansion and Collapse

The earliest permanent white settlement buildings in Portland dated to the 1840s, but by the 1890s, little remained. The city had endured booms, busts, floods and fires. During this period, some older buildings found themselves physically relocated and repurposed, such as the Captain Nathaniel Crosby House, built around 1847 and long purported to be the first frame house erected in the city. The Crosby House originally stood near the Willamette River on Southwest Washington Street, but by the time of its demolition, around 1910, it stood near Southwest Fourth Avenue and Yamhill Street, serving as a commercial storefront.

Between the 1890s and the United States' entry into World War I in 1917, several prominent Portland buildings were erected and lost. It was a period in Portland's history with an inordinate amount of short-lived buildings. Some were simply outgrown and replaced, but there was also at least one epic building failure. The gradual expansion of the city to the west, away from the flood-prone Willamette, erased residential areas once at the outskirts of town, replacing them with substantial new commercial buildings. Fire played a significant role in the loss of buildings, much as it always had, but the biggest impact was the result of a growing city leaving many buildings in untenable locations.

PORTLAND CATHEDRAL

Perhaps no other lost Portland building had such a short life as the Gothic Catholic cathedral that once stood prominently on the northeast corner of Southwest Third Avenue and Stark Street.

In 1851, pioneering Portland landowner Captain John H. Couch donated land near Northwest Sixth Avenue and Davis Street for a small Catholic church, the first to be dedicated in the city. As the city grew, so did the congregation, and in 1854, the church building was moved to a new location near Southwest Third Avenue and Stark Street, where it was also enlarged. Even with the larger building, the congregation outgrew the facility by the mid-1870s, and with Portland now firmly established as the center of Catholicism in Oregon, the construction of a cathedral seemed inevitable.

Under the direction of Father J.T. Fierens, the church hired San Francisco–based architect and engineer Prosper Louis-Etienne Huerne to design a cathedral and adjacent Bishop's House (still extant). An immigrant from France, Huerne was well into a career that first brought him to the Bay Area around 1850, where he established a successful firm best known for its engineering work on mines, railroads and early efforts to build the Panama Canal. Construction for the new Portland Catholic Cathedral began in the late summer of 1878. As the new building took shape, the old church dating to the 1850s and sharing the same property was torn down.

The foundations for the new cathedral were finished rapidly, so much so that, by early 1879, the basement was being used for church services.[1] At the same time, the brick and stone building was still several years from completion. Dedication of the cathedral did not occur until August 1885. The new building's main entrance was on Stark Street, where it stood about 60 feet wide, but along Third Avenue, it was most impressive. At 150 feet in length, the cathedral nearly filled the block between Stark and Oak Streets. A 100-foot tower projected from the roof. Plans called for a spire that would have extended another 100 feet above the tower, but that was never completed.

On the inside, the cathedral was equally impressive. A variety of donors helped fund stained-glass windows, including Ben and Esther Holladay, who lived kitty-corner from the cathedral. Ben Holladay had once been one of the wealthiest men on the West Coast, helping to bring the railroad and early streetcars to Portland. Beginning in 1873, with the nationwide financial panic and after a series of sketchy business

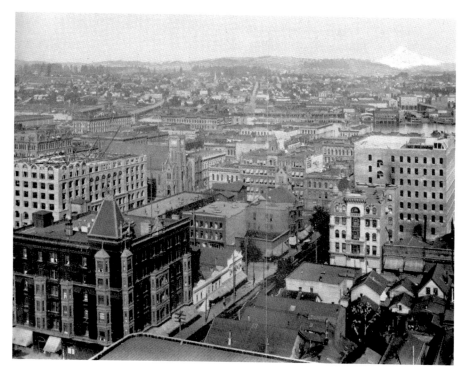

Section of Portland panorama taken from Oregonian Tower, Portland Cathedral at center, 1892. *Architectural Heritage Center Library.*

deals, Holladay began to lose much of that wealth, never again attaining such status. Even though he was no longer a man of enormous capital wealth, his support of the cathedral was certainly a means to maintain his presence in Portland society.

The 1880s was a decade of dramatic growth in the downtown area; by the early 1890s, what had once been tree-lined residential streets a few blocks from the river were now being turned into commercial thoroughfares. This included much of Third Avenue and the block on which the cathedral stood. In 1894, only nine years after the building was dedicated, it was surrounded by business blocks. That October, the church announced plans for a new cathedral in northwest Portland. Within weeks, demolition began at the Third and Stark cathedral, continuing into the following year. A two-story brick commercial building that still occupies the site replaced the cathedral.

CENTRAL SCHOOL

Constructed in 1858, a year prior to Oregon statehood, the Central School was the first public school building built in the young city of Portland. Located on the block between Sixth Avenue, Seventh (Broadway), Morrison and Yamhill Streets, the school was several blocks away from the hustle and bustle of the business district nearer the river. In 1869, construction of the Pioneer Courthouse across the street from the school began, marking the beginning of an era of major westward movement in the city. In 1872, an addition to the school added space for Portland's first formal high school. Within a few years, grand estates filled entire blocks nearby and new commercial buildings were soon to follow. By the end of the decade, the school was too small for the growing enrollment and the location seemed far more appropriate for commercial development.

In 1882, new schools opened in locations to the south (Harrison School) and north (Couch School). Both were closer to the residential districts in the inner west side of town. In February 1883, the Portland School District sold the Central School property for $75,000 to the Northern Pacific Terminal Company for development of the Portland Hotel, although it would be

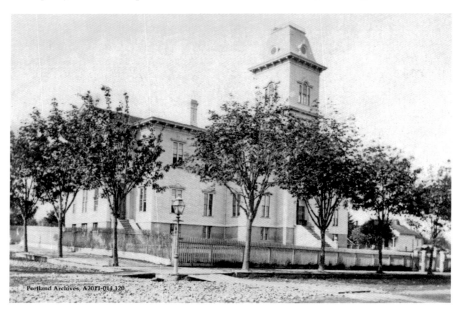

Central School, circa 1870. *City of Portland (OR) Archives, A2011-014.120.*

another seven years before the hotel actually opened. After the sale, the Central School building was split into two parts and moved to nearby properties. The buildings served a variety of purposes before they were eventually demolished.

The site on which the school once stood provides a remarkable example of how downtown Portland has changed over time. While the area is now the heart of downtown, when construction of the Central School began, it was predominately a residential area. The hotel that replaced it was an icon of Portland architecture for several decades before it met the wrecking ball in 1951. The parking lot that replaced the hotel lasted thirty years before Pioneer Courthouse Square took its place, opening in 1984 and remaining to this day as Portland's "living room."

INDUSTRIAL FAIR EXPOSITION BUILDING

Located along the south side of what is now West Burnside Street between Nineteenth and Twentieth Avenues, the Industrial Fair Exposition Building was erected in 1889. It was the one and only major project for the short-lived architectural firm of Richard Martin Jr. and Alexander M. Milwain. Both Martin and Milwain had served as draftsmen for prominent Portland architects Warren H. Williams and Justus F. Krumbein, respectively, before venturing out on their own in early 1888. Martin would go on to a have a lengthy and successful career in Portland, while Milwain would leave Portland altogether within five years of the Exposition Building's construction.

At four hundred feet long and two hundred feet wide, the Exposition Building occupied two full city blocks and was twice as large as the Mechanics' Fair Pavilion it was built to replace. It was built in 1878 and located at Southwest Third and Market Street, but within a decade, the city had outgrown the Pavilion. An ever-increasing number of large annual agricultural, science and art expositions, along with frequent smaller events, such as pioneer reunions, necessitated the larger facility.

The three-story Exposition Building had more than 100,000 square feet of exhibit space, making it the largest exposition hall on the West Coast. With dedicated sections for displaying everything from farm equipment to artwork, the building appealed to the broadest possible audience. Several thousand electric lights illuminated the building interiors. Inside, there were enormous gardens, a zoo and an aquarium.

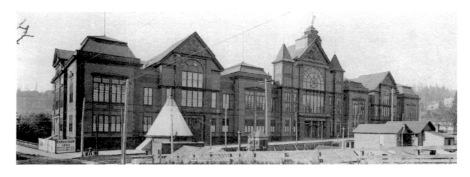

Industrial Fair Exposition Building, 1892. *Architectural Heritage Center Library.*

In the early morning hours of July 14, 1910, an enormous fire broke out in the building. By the time the fire was out, the wood-framed structure lay in ruins along with several of its neighbors, including the Multnomah Athletic Club. At least two people died in the fire, as did the nearly two hundred horses housed in the building's stables. Although plans for a new and much more grand Exposition Center were proposed for the site merely weeks later, the project never materialized. Instead, expositions were held at a variety of sites around the city for the next several years, including the armory, in what is now the Pearl District, and the Civic Auditorium, built on the site of the old Mechanics' Fair Pavilion. In 1921, the Pacific International Livestock Association, in far north Portland, built a complex and began hosting a variety of expositions. The site was later transformed into the Portland Expo Center, still in operation. Meanwhile, the Multnomah Athletic Club rebuilt its clubhouse and, in the 1920s, added a stadium that still stands adjacent to where the old Exposition Building stood.

MULTNOMAH COUNTY COURTHOUSE

Believed to have been the first domed building in Portland, the original Multnomah County Courthouse stood on the downtown block bounded by Southwest Main Street, Salmon Street, Fourth Avenue and Fifth Avenue. In 1864, architects Elwood M. Burton and William W. Piper won the design competition for the new county courthouse. Burton was familiar to Portlanders. He, along with his wife, Rhoda, and their three children had come to Portland from Iowa in 1854, just months before Multnomah

County itself was created from parts of Clackamas and Washington Counties. Piper, on the other hand, was not so well known and had only been in Portland a short while, reportedly having come to the city from New Hampshire by way of Ohio.

Dedicated on August 6, 1866, the courthouse was an imposing stone and brick edifice among much smaller neighboring buildings and nearby public parks. The T-shaped building resembled a Greek temple in some respects, with large pediments at each gable end. The building also featured Italianate pairs of brackets supporting the roof cornice. The courtroom contained twenty-four-foot-tall ceilings, illuminated by tall, narrow windows that lined the building's two main floors. At the time of construction, there were no other large public buildings in town other than school buildings. Construction on the new federal (Pioneer) courthouse did not begin until 1869, and it would still be another thirty years before the Portland City Hall, located only a block from the courthouse, would finally be constructed.

As the population in Multnomah County and in the state in general continued to increase, so did the need for more room for the county and circuit courts using the courthouse. By 1891, judges were calling for a new courthouse to be constructed on the same block as the existing building.[2] One

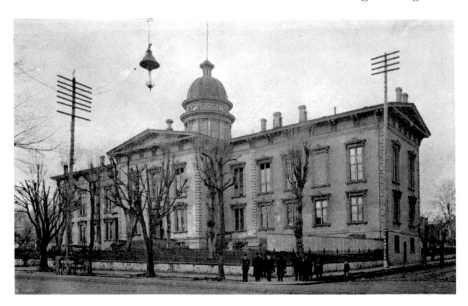

Multnomah County Courthouse, circa 1900. *Architectural Heritage Center Library.*

proposal that gained favor was to construct a new courthouse in sections, as funding allowed, keeping the aging courthouse in use for as long as possible. The county hired architect Isaac Hodgson Jr. to design a new building, but the project soon fell apart, with Hodgson claiming he was never paid for his design work. By 1894, talk of a new building dwindled, along with the Portland area economy. A few updates were made to the old building over the next decade, but it took until 1908 for the county to once again seek funding for a new courthouse.

Construction began on the new Multnomah County Courthouse in 1909. Erected on the same site as its predecessor, the new building was constructed in sections, similar to the suggested approach from years earlier. In the summer of 1911, the first portion of the new courthouse, the side facing Fourth Avenue, was finally completed. The remaining section to the west was finished in 1914, removing all traces of the original building. This building is still standing, but as of this writing, a new replacement courthouse is under construction a few blocks away at the foot of the Hawthorne Bridge.

MARQUAM BUILDING

When its first section opened in February 1890, the Marquam Building represented a new era in Portland's growth, both architecturally and culturally. The eight-story, two-hundred-foot-long building was the first of several "modern Romanesque" commercial buildings to be constructed in a city that was just coming out of its Italianate, heavy-ornamented phase.[3] The redbrick, stone and terra-cotta exterior of the Marquam complemented the nearby Portland Hotel, nearing completion just across Southwest Morrison Street. Built as essentially two separate structures, the west end of the building facing Seventh (Broadway) provided access to the new Marquam Grand Opera House. The eastern end, along Sixth, and most of the Morrison Street frontage, housed offices and ground-floor storefronts.

Judge Philip A. Marquam was one of the many Portland pioneers to have wisely invested in real estate away from the river and its frequent flooding problems. He came to the fledgling Portland in 1851 after having spent a few years in the gold rush areas of California, where he had practiced law. In 1862, Marquam became a Multnomah County judge, holding that position for eight years before retiring. He then devoted much of the rest

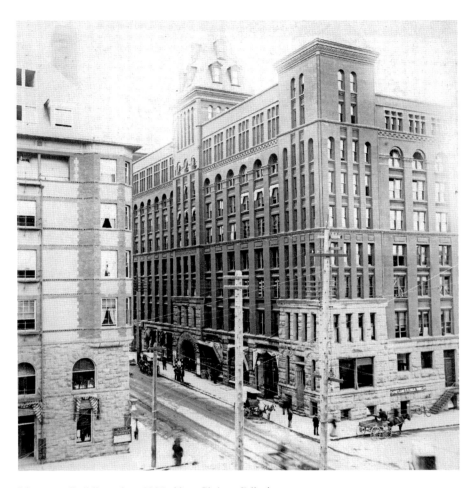

Marquam Building, circa 1895. *Norm Gholston Collection.*

of his life to his real estate, which included hundreds of acres, making him one of the largest landowners in Multnomah County. Marquam Hill, the location of Oregon Health and Science University and the Marquam Bridge over the Willamette River, are but two of the existing landmarks that bear his name.

Unlike some of his wealthy contemporaries, Philip Marquam did not have multiple buildings scattered about the city with his name on them. What he did have among his holdings was a large piece of land along Southwest Morrison between Sixth and Seventh Streets that, by the end of the 1880s, was ripe for redevelopment. In May 1889, Marquam hired nationally known

theater designer Colonel James M. Wood to design his new building. Based in Chicago, Wood had designed theaters all over the country and at the time was also working on designs for a new theater in Tacoma, Washington. The theater portion of the Marquam Building opened to great fanfare on February 10, 1890; it took another year and a half to complete the remaining section of the building.

The arrival of the Marquam signaled the beginning of Portland's theater district along what is now Southwest Broadway. Several new theaters sprang up in the ensuing decades. Meanwhile, the Marquam, as both theater and office building, seemed, for a time, a resounding success. The theater hosted operas, plays and music performances, and even a lecture by Samuel Clemens as Mark Twain.[4] The commercial office spaces were also in high demand, attracting longtime Portland businesses and even a few architects, including Justus F. Krumbein. As successful as things seemed, the 1890s saw major financial challenges for many Portlanders, including Philip Marquam. The building was lost to foreclosure in 1896, and Marquam died on May 8, 1912.

Not long after Marquam's death, his former building underwent a series of renovations intended to give it more structural support by replacing some of the stone walls with steel beams.[5] In the early morning hours of November 21, 1912, the northeastern corner of the building began to collapse. By midday, multiple floors had collapsed one upon the other as crowds of onlookers watched in amazement. The commercial office wing of the building was deemed a total loss and was soon demolished. The theater was not as badly damaged but was still forced to close. George Baker, a city council member and future mayor, eventually reopened the theater under his name.

To this day, there has never been another unintended building collapse of this scale in Portland. Immediately after the collapse and demolition, work began on a replacement building. The Northwestern Bank Building, designed by Albert E. Doyle, opened in 1914. It still stands on the site today, with its white glazed terra-cotta exterior a dramatic difference from the redbrick and stone building that preceded it. Surrounded and nearly encapsulated by the tall buildings adjacent to it, the old Marquam Grand Opera House portion of the Marquam Building survived the collapse and stood until the 1920s, when an addition to the Northwestern Bank Building led to its demolition.

PORTLAND LIBRARY

The Library Association of Portland formed in 1864 as a subscription-based service, charging modest fees for access to an ever-growing number of books, periodicals and newspapers. Although the library paid only one dollar per year for renting the second floor of the Ladd and Tilton Bank, on Southwest First Avenue and Stark Street, by the end of the 1880s, the association needed a new and much larger facility. In 1890, Judge Matthew Deady, president of the association, announced plans for a new library building on the southwest corner of Seventh (Broadway) and Stark Street. The architectural firm of Whidden and Lewis designed the new building. After some delays in construction, the library opened in the summer of 1893, just as the city entered into an economic depression lasting several years. The *Oregonian* described the building as an "ornament to Portland," saying, "no other structure [in the city] is architecturally more perfect."[6]

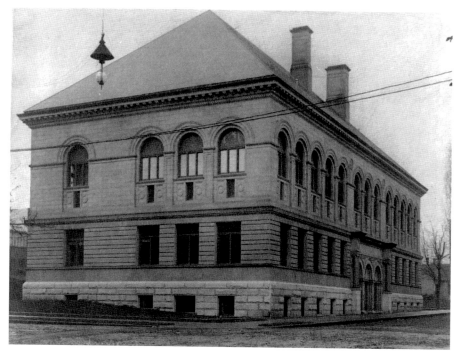

Portland Library, circa 1903. *Library of Congress, PPMSCA-15381.*

The building was not imposing but both modern and modest for its time. Each floor of the sandstone exterior was finished differently. The basement level was heavy and rustic, the two upper floors more smooth in texture. Round arches over the second-story windows and main entrance along Stark Street gave the building a Romanesque feel, but the dentils at the cornice presaged the coming popularity of the Classical Revival style of architecture for which Whidden and Lewis would become famous. The soaring hipped roofline on the building added a hint of the French Chateau and was reminiscent of the roofline on the Portland Hotel, which architect William Whidden had worked on only a few years earlier. The building's interior must have been impressive, with its variety of details in marble, brass and oak as well as the thirty-foot vaulted ceiling in the second-floor reading room.

In 1900, the Library Association of Portland received a bequest of more than eight thousand books from John Wilson, a Portland pioneer and business owner, with the condition that they be freely accessible to the public.[7] Soon, membership fees were eliminated, and in 1902, the Portland Library officially became the Portland Public Library, gaining its financial support from area taxpayers. Under the leadership of librarian Mary Frances Isom, the library soon realized it was outgrowing its building, which at the time it had occupied for little more than a decade. Working with Multnomah County, Isom and the library association secured a site and funding for the new Multnomah County Central Library, which opened in September 1913.

The demolition of the old library began in November 1913, on the heels of plans announcing a new theater and office building on the site. The library was barely twenty years old and seen by some as "one of the greatest of Portland's landmarks," yet it was still deemed expendable.[8] The theater opened in 1914, running through a series of owners (and names) before operating as the Liberty Theater for many years before closing in 1959 as it, too, met the wrecking ball. The Union Bank of California building, which opened in 1969, now occupies the site of the old Portland Library.

ST. HELENS HALL

Founded in 1869 by the Episcopal Church of Oregon and Washington, St. Helens Hall served as a girls' private school for a century before merging with another local school to become the Oregon Episcopal School. The

name for the school came from Saint Helena, the mother of ancient Roman emperor Constantine. The original school was located on Southwest Fourth Avenue on the block where the Portland City Hall now stands. Enrollment at St. Helens Hall grew rapidly, and by the early 1880s, it was outgrowing the original location while recognizing that the continued expansion of downtown would soon render the school's location unsuitable.

Construction on a new four-story facility began in 1890, and the school opened in 1891. Located high above downtown on the block bounded by Southwest Vista and St. Clair Avenues, Main Street and Park Place, the location made the school an instant hillside landmark. Architect Henry J. Hefty's design reflected the popular Romanesque Revival style of the time, especially the heavy stone and brick exterior. At the same time, his use of towers, gables, brackets and finials was more in line with the popular Queen Anne style, typically seen in houses from the period. From the front, the overall shape of the building was similar to that of the Portland Hotel, which opened while Hefty was still working on the St. Helens Hall design. Around this same time, the City of Portland hired Hefty to design a new city hall. As expenses mounted and the City became dissatisfied with his work, that project fell apart. Hefty's ornate and towered Portland City Hall never got beyond the building of its foundations.

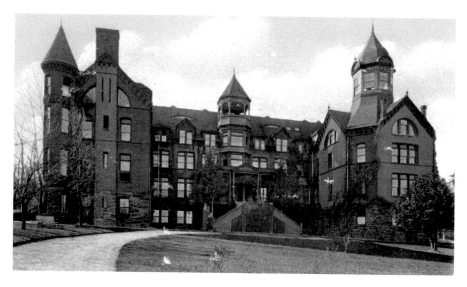

St. Helen's Hall postcard, circa 1909. *Architectural Heritage Center Library.*

By 1910, the neighborhood around St. Helens Hall had turned into one of the city's finest residential areas. Thinking that, yet again, they needed a new facility, school officials began looking still farther away from downtown while trying to sell their current home. Construction of a new school was far from a certainty, but all their plans changed in dramatic fashion when, on September 3, 1914, only a week before the beginning of fall classes, a fire in the basement laundry facility of St. Helens Hall gutted the building. Within months, the building was gone, its wreckage sold by local building salvagers.

St. Helens Hall lived on. Classes were held in the Episcopal Bishopcroft, several blocks away in Portland Heights, while the school's administrators determined a more permanent solution. One plan was to build a new facility in far northwest Portland on property they owned near the intersection of Skyline Boulevard and Germantown Road. Another concept was to rebuild on the site where their building had burned. Neither of these options ultimately worked out; in 1918, the school moved into the recently closed Portland Academy building on Southwest Thirteenth Avenue. Their desire to move away from downtown took nearly half a century longer to achieve. In 1964, the Thirteenth Avenue building was demolished to make way for the Interstate 405 freeway. At that time, the school moved to a new location on Nicol Road in southwest Portland, where Oregon Episcopal School still operates today.

LEVI WHITE HOUSE

The Eastlake-style Levi White House was one of the many grand houses of late nineteenth-century Portland to stand for an inordinately short period of time. Located on the full block bounded by Northwest Glisan, Hoyt, Twentieth and Twenty-First Avenues, the White homesite has been the location of Couch School (now the Metropolitan Learning Center) since 1914.

Levi White arrived in Portland at age twenty-five in 1858, opening a dry-goods store on Front Avenue. The store prospered. After several successive (and very successful) business partnerships, White retired in 1883 as one of the wealthiest people in the city. White soon enlisted architect Justus F. Krumbein to design his new house just across the street from the Captain Flanders house, also designed by Krumbein a few years prior.

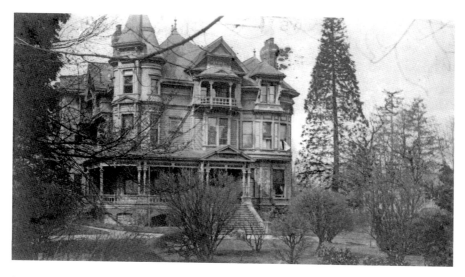

Levi White House after its conversion into a sanatorium, circa 1910. *Norm Gholston Collection.*

The White house design was Krumbein at his most extravagant. When it was nearing completion in 1887, the *Oregonian* noted, "The [house] style is modern, and the architectural effect odd, even to grotesqueness…with all sorts of quaint turns, angles, niches, gables and unique ornamentation."[9] Indeed, the multi-gabled house provided plenty of surface area for the latest in architectural ornament, including an oval-shaped corner tower that punctuated the three-story mansion. On the more practical side, an ornately decorated wraparound porch provided fresh air and protection from the elements.

White's first wife, Henrietta, died less than two years after they moved into their new house. In 1893, Levi White married Zipporah Frank. The couple had lived in the house only a short while when Levi White died in January 1895. At the time of his death, he had an estate worth about $165,000 (the equivalent of nearly $5,000,000 in 2018). In addition to the house, White owned buildings in downtown Portland as well as several acres of land around Mount Tabor. After White's death, his widow moved out of the house. Within a few years, it was being operated as the North Pacific Sanatorium, run by a medical doctor named Robert C. Coffey. In 1908, the Roman Catholic Church of Oregon purchased the house and property with plans to build a new cathedral on the site. Those plans never came to fruition; instead, the church sold the house and property to the Portland

School District, which demolished the house and built a new school on the site in 1914. All told, the Levi White House served as a residence for less than a decade and was only twenty-seven years old when it met its demise.

TAYLOR STREET METHODIST CHURCH

In 1850, months prior to the incorporation of Portland as a city, a small Methodist Episcopal church opened near Southwest Second Avenue and Taylor Street. This was Portland's first dedicated church building. In 1867, construction began on a new building to house the growing congregation. Commonly referred to as the Taylor Street Methodist Church, it quickly became a downtown landmark. Located at Southwest Third and Taylor, the Gothic church with its spire rising high above the street appears in many photos of Portland taken in the late nineteenth and early twentieth centuries.

John Nestor designed the church. Nestor's background as an architect remains unknown, but he arrived in Portland around 1865; by the beginning of 1867, he was regularly advertising in the *Oregonian* as an architect of "first class residences…churches, tenements, cottages…designed and planned with accuracy, and scrupulously and faithfully superintended."[10] Nestor's career in Portland was short. As work wrapped up on the Ladd and Tilton Bank he designed, soon after the church project, Nestor left the city to seek opportunities elsewhere. He returned to Portland around 1874, before moving to the town of Cornelius in Washington County and later moving to the Seattle, Washington area, where he designed another Methodist Episcopal church.

Completed in 1868, the Taylor Street Methodist Church was one of several houses of worship that, by the 1870s, dotted the Portland landscape on the blocks between Sixth Avenue and the Willamette River. As the city grew up around these buildings, the congregations slowly moved west, away from the bustling downtown. In 1884, a new congregation, Grace Episcopal Church, broke away from the Taylor Street congregation and, by the end of the decade, had built a new edifice farther west on Taylor Street at Twelfth Avenue. Although the congregation continued to grow, in 1891, the church sold a portion of its property on Taylor for construction of the Ancient Order of United Workmen Temple. By 1911, the church was still considering expanding its aging building, but the following year, church leaders elected to reunite with Grace Episcopal instead, intending that the Taylor Street

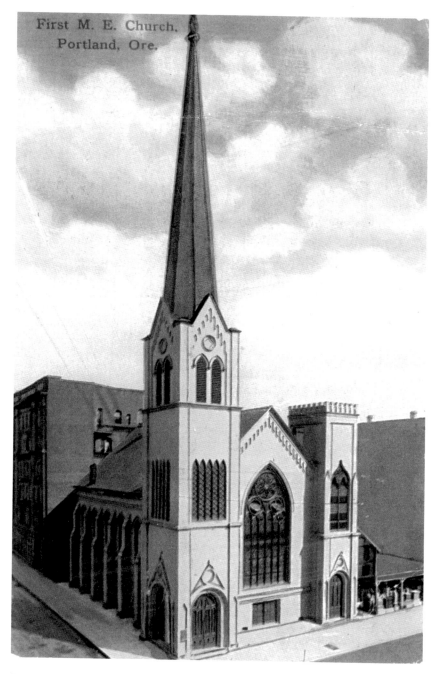

Taylor Street Methodist Church postcard, circa 1910. *Architectural Heritage Center Library*.

congregation would relocate to Grace's Twelfth Avenue facility. The merger subsequently led to several years of infighting between the two congregations, with a minority of Taylor Street congregants seeking to continue services at their old Third and Taylor location. By 1915, however, their old church was locked up. On more than one occasion, the small congregation held services on the street outside its old church. Repeated efforts to allow the church building to reopen were all turned away; in the fall of 1917, the Taylor Street Methodist Church was demolished.

After the 1912 merger, the Twelfth Avenue location of Grace Episcopal was renamed First Methodist Episcopal. The stone church it occupied had been built in 1888, one of several churches and synagogues in the area between the Park Blocks and Twelfth Avenue. Many of the old houses of worship in this area are still standing, but First Methodist Episcopal relocated again in the 1950s to a new site even farther west at Southwest Eighteenth and Jefferson Street. The 1880s church was subsequently demolished, and the site is now a surface parking lot.

2

1922–1929

The Blazing 1920s

After the end of the First World War, the Portland economy slowly picked up, and the 1920s became a decade of new house construction around the city. Meanwhile, downtown saw its own period of change as new and larger buildings replaced landmark houses and commercial buildings erected by the city's founders and other early residents.

It was a time of real estate speculation and formalized racial segregation. With the growing presence of the automobile, direct access to streetcar lines was no longer an absolute necessity. New residential neighborhoods began to fill in the city in areas not previously developed. These neighborhoods were not always welcoming to everyone. African Americans had few opportunities to rent or buy into newly developing parts of town. Instead, their options were limited through the organized efforts of realtors and pointed opposition to their presence by white residents. As a result, the older east side neighborhoods in north and northeast Portland, where white northern European immigrants had first settled, became the center of Portland's African American community.

During the 1920s, tragic fires destroyed important and landmark Portland buildings, displacing students and religious congregations. These losses paved the way for new construction utilizing modern building methods, but not necessarily the latest architectural styles. By the end of the decade, the grand old houses that once lined streets adjacent and near the South Park Blocks, south of Taylor Street, were mostly gone—replaced by new apartments and commercial buildings.

Demolition was commonplace, even for buildings less than twenty years old. Building "wreckers" salvaged usable pieces for reuse elsewhere, but there was yet to be much interest expressed in saving buildings from the wrecking ball. Had anyone been able to predict the future, such wanton demolition might have been avoided and some buildings may have stood many years longer. Instead, new building projects came to a halt as the Great Depression emerged, leaving empty lots, some of which remained that way for decades.

WASHINGTON HIGH SCHOOL

In the days before there was a dedicated high school in the old city of East Portland, several rooms in the East Side Central grammar school located on the property bounded by present-day Southeast Stark, Alder, Twelfth and Fourteenth Avenues were adapted for high school classes. After East Portland merged with Portland proper in 1891, students of high school age from the east side of the river had to cross either the Morrison or Madison Street bridge and pass through downtown to reach the city's only formal high school. By 1900, eastside parents and teachers were clamoring for a new high school building, yet it took until 1905 before the Portland school board approved plans to build a new facility—on the same block as the East Side Central School.

The Portland school district's official architect, Thomas J. Jones, designed the new high school to be "up to date in every respect."[11] The three-story building, plus basement, was built of brick, sandstone and terra-cotta on the exterior. Classrooms had fourteen-foot ceilings; there was a large auditorium with a balcony and separate lunch rooms for boys and girls. The school admitted its first students in February 1907 and had more than one thousand students enrolled by the following school year. The school was a success, but from the outset, critics declared the new building dangerously "behind the times" because the latest in fire safety measures were not included in the design. The sandstone on the exterior was deemed particularly hazardous in a fire, as were the limited and centrally located entrances and exits.[12]

The East Side High School was crowded; almost immediately after it opened, the school district began looking to build a second high school on the east side of the river. By the end of 1908, it had selected a new site in north Portland. This new school would be the first "fireproof" high school in Portland. As work got underway on this new school, the district renamed

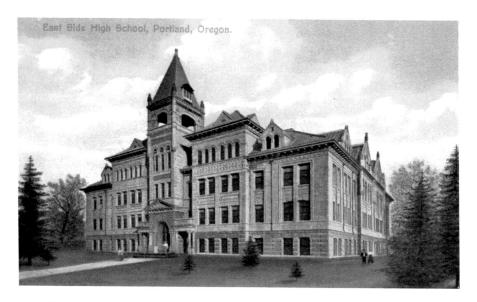

East Side High School postcard, circa 1908, prior to its renaming as Washington High School. *Architectural Heritage Center Library.*

all three Portland high schools, with East Side High School becoming Washington; the old West Side High School became Lincoln; and the new north Portland school was renamed Jefferson.

In 1912, a three-story brick gymnasium was built adjacent to Washington High School. Architect Ellis F. Lawrence designed this new fireproof building. Lawrence designed hundreds of buildings in Oregon during his lengthy career, but he is perhaps best remembered for serving as the founding dean of the University of Oregon's School of Architecture and Allied Arts from 1914 to 1946.

Like many Portland buildings lost during the early twentieth century, the original Washington High School had an amazingly short lifespan. In the early morning hours of October 25, 1922, fire ripped through the fifteen-year-old school, killing one firefighter. The main school building was a total loss, while the gymnasium survived. The cause determined to have been arson, investigators later suspected Portland firefighter Chester C. Buchtel of starting the blaze, but he never admitted to it. Arrested in early 1925, Buchtel confessed to starting dozens of fires in Portland between 1922 and 1925.

Construction on a new Washington High School began in late 1923. Designed by the architectural firm Houghtaling and Dougan, the new

school saved on construction costs by employing the foundations from the burned-out building. That school remained open until 1981 and then languished for many years before it was converted into office and restaurant spaces, as well as a music venue. The gymnasium that survived the 1922 fire stood until 1960.

CHARLES AND HEDWIG SMITH HOUSE

Lair Hill Park, located between Southwest Second Avenue and Barbur Boulevard, between Hooker and Woods Streets, is a small city park with a former public library in one corner and a building from 1918 that used to serve as a residence for nurses in another. The nurses' building is a clue to what once stood in the park a century ago: a mansion turned hospital.

Charles E. Smith was one of the city's largest employers before the turn of the twentieth century. His Smith Brothers and (later) Watson Iron Works Company produced ornamental and structural cast iron for buildings, steam boilers for ships and mining equipment, selling its wares all over the world. Its foundry stood along the river, just south of the Hawthorne Bridge in the area known today as Riverplace. The company's main office stood just a few blocks away, at the northeast corner of Southwest First and Main, the present site of Three World Trade Center.

In 1885, Charles Smith and his wife, Hedwig, hired Justus F. Krumbein to design a new house for them. By this time, Krumbein was at the height of his architectural career, finishing work on the Kamm Block while designing houses for other noted Portlanders, including one in northwest Portland for Levi and Henrietta White. The Smith House, finished around the end of 1886, was indicative of Krumbein's residential designs from that period. The three-story house had a large corner tower; the ornate exterior woodwork, much of it made of durable Port Orford cedar, included finials, brackets, turned columns and a variety of spindlework on the wide front porch. On the interior, many of the walls and ceilings were hand-painted, with cherubs, flowers and a variety of imagery. One room in particular was later noted for its "mystic oriental designs."[13]

The Smiths lived in the house until around 1909, when they sold the house and property to Multnomah County so that it could be turned it into a new hospital. This was not the first grand old Portland house reused in such a manner. The Levi White House had become a private

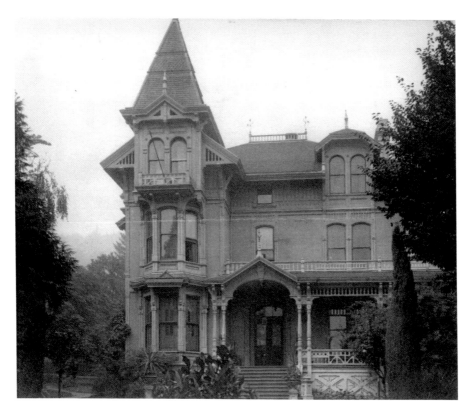

Charles and Hedwig Smith House after it was acquired by Multnomah County, circa 1909. *Oregon Health & Science University, Historical Collections & Archives.*

sanatorium only a few years earlier. By the time they sold the house to the county, Charles Smith had been in poor health for many years. He died in 1912, around the time that Hedwig and son-in-law Charles Schnabel were overseeing completion of their new investment, the Congress Hotel at Southwest Sixth and Main.

The new Multnomah County Hospital, in the refurbished house, opened in 1912. The structure was never really considered a long-term solution to the need for a new hospital; within a few years of opening there were cries that it was inadequate and possibly a firetrap.[14] In the meantime, Multnomah County was beginning to consider a move to the top of Marquam Hill, more or less overlooking the Smith house hospital site in South Portland. In 1916, the University of Oregon Medical School offered a piece of land on its hilltop property to the County.

In August 1923, the first patients moved into the new County hospital on Marquam Hill. The demolition of the Smith House–Multnomah County Hospital began only a couple of months later. Meanwhile, at the northern end of the property, a new Carnegie-funded library branch neared completion. In 1927, the remaining property where the Smith House once stood became Lair Hill Park.

BETH ISRAEL SYNAGOGUE

Congregation Beth Israel has been in Portland since 1858. Its first dedicated synagogue, located at Southwest Fifth and Oak Street, was built in 1861. Today, the congregation occupies one of the most architecturally spectacular buildings in Portland. Located at Northwest Nineteenth Avenue and Flanders, the current building, dedicated in 1928, was a replacement for the 1880s synagogue that famously burned in 1923.

In May 1887, the congregation purchased property at the southwest corner of present-day Southwest Twelfth and Main Street, announcing plans to build a new synagogue. The initial designs for the building came from the office of architect Warren H. Williams, but after his sudden death in January 1888, Williams's brother Franklin and son David L. took over the firm and, therefore, the synagogue project. The building was an impressive addition to the Portland skyline, with twin steeples topped by galvanized iron domes and spires soaring 165 feet in the air.[15] The domed steeples were very reminiscent of Temple Emanu-El, built in San Francisco in the 1860s, the city from which Warren H. Williams had come to Portland. Stained-glass windows shipped from Chicago lined the building's exterior walls, the most prominent being a giant rose-type window over the main entrance. Gas lighting supplemented the natural light cast through the windows into the main sanctuary with its 50-foot ceiling. The pipe organ cost a reported $5,000 (more than $125,000 in 2018). Construction of the new synagogue coincided with work on other nearby houses of worship, signaling a major change for what had been a mostly residential neighborhood. In late June 1889, the new synagogue opened to great fanfare.

Beth Israel Synagogue is particularly noteworthy for its connection to Rabbi Stephen S. Wise. Wise became rabbi of Beth Israel in 1900 and is notable for his support of social issues, including woman suffrage and workers' rights. At the same time, Wise was an outspoken proponent of

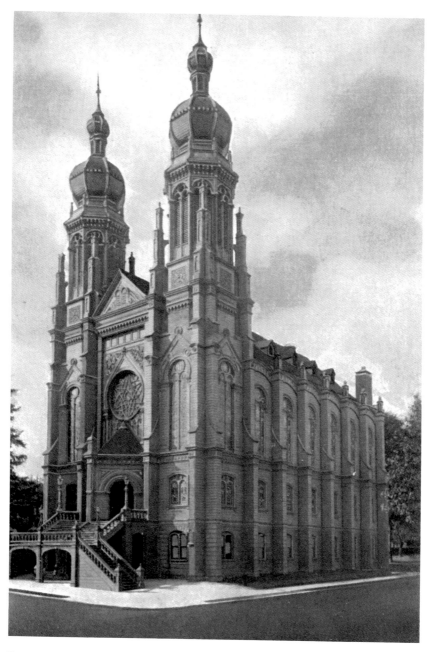

Beth Israel Synagogue postcard, circa 1910. *Architectural Heritage Center Library.*

Zionism, the creation of a Jewish state in Palestine. After Wise left Portland in 1906, he remained a prominent Jewish leader, founding the New York Free Synagogue and later the World Jewish Congress.

On December 29, 1923, a massive fire ripped through Beth Israel Synagogue. When firefighters arrived on the scene, they immediately saw evidence of arson—gasoline was clearly "sprinkled about" the building.[16] Over the course of several hours, the roof collapsed and the interior of the building was completely gutted. After the fire, the only things left standing were parts of the brick exterior walls and the framing of the once ornate steeples. The fire occurred only two months after another arson fire at the nearby Ahavai Sholom Synagogue. Firefighters were able to put out that blaze before it got out of control, and the building was saved. It took more than a year before Portland firefighter Chester C. Buchtel was arrested, eventually confessing to starting the two synagogue fires and several dozen others in the city in the first half of the 1920s. He was declared insane and sentenced to the Oregon State Hospital.

Within a few weeks of the fire, a rebuilding effort began. Meanwhile, the congregation completed the building of a new school on a lot adjacent to the site of its burned-out synagogue and began using that facility for its services, too. At the end of 1924, the congregation selected a new building site in northwest Portland that remains its home to this day. Meanwhile, the Southwest Twelfth and Main site is now a surface parking lot, while the adjacent school building remains.

HENRY FAILING HOUSE

Located on an entire city block in what is now the heart of downtown Portland, the Henry Failing House was located between Southwest Fifth, Sixth, Salmon and Taylor Streets. The Failing House and its neighbor to the north, the Corbett House, exemplified the economic successes of the two families.

Henry Failing arrived in Portland in 1851, joining his father and brother to run a successful store on Front Avenue. Within a few years, he became majority owner in the business and, by the early 1870s, had already served as the city's mayor (1864–66) and as president of the First National Bank of Portland, a position he held for nearly thirty years.[17] Not long after his wife (and sister to Henry Corbett), Emily, died in 1870, Henry Failing sought to

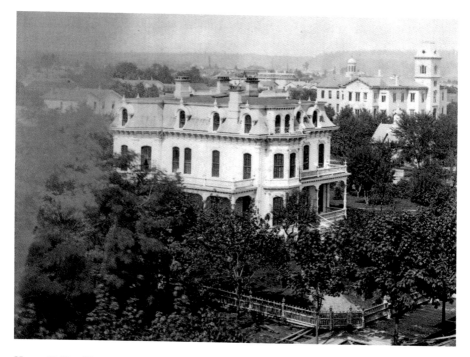

Henry Failing House with Central School in upper right, circa 1875. *Norm Gholston Collection.*

have a new house constructed. He hired one of the West Coast's most noted architects at the time—Henry Cleaveland of San Francisco. Cleaveland's design for the house was of the French Second Empire style, popular at the time with other members of the Portland elite. The Jacob Kamm House, standing on Southwest Twentieth Avenue off Jefferson Street, is perhaps the only remaining example of a Second Empire house in Portland.

Work on Failing's new house began in 1873, just as he successfully ran to become mayor of Portland for a second time. Little expense was spared in constructing the house. Cleaveland sourced many of the building materials from California, partly because there was a shortage of wood products in Portland following the great fire of August 1873.[18] Henry Failing and his three daughters moved into the house in 1875.

The Failings moved into the house before it was completed. Work continued on details such as the elaborate interior painting that was not finished until 1882.[19] The house boasted a wraparound porch with columns supporting a second-story veranda. Round-arched dormer windows, replete

with decorative finials, added light to the mansard-roofed attic, which extended above a heavily bracketed cornice. Inside the house, plaster and woodwork details, including built-in bookshelves and doorway pediments, complemented the ceiling frescoes.

Henry Failing died in 1898, but the family continued to live in the house until 1922. In early 1924, the house was demolished to make way for the Public Service Building and its adjacent parking garage, both designed by architect Albert E. Doyle. Those buildings stand on the block to this day.

ELKS LODGE

The Portland Elks Lodge was, arguably, one of the nicest buildings with the shortest lifespan in Portland history. Located on the northeast corner of Southwest Broadway at Stark Street, construction of the Elks Lodge began in late 1904. Architect Richard Martin Jr. designed the building. Martin had been practicing architecture in Portland since the late 1880s and only a few years earlier had designed another of the city's noted fraternal lodges, the Scottish Rite Temple. That building still stands at Southwest Fifteenth Avenue and Morrison Street.

The Benevolent and Protective Order of Elks, Portland Lodge Number 142, had been in existence since 1888, at which time it had a membership of only forty men. In its early years, the lodge never had a permanent home of its own, meeting in a variety of buildings while its numbers continued to grow. By the early 1890s, membership had increased to more than four hundred, and the lodge took over the entire top floor of the Marquam Building (another piece of Portland's lost architectural heritage), which once stood on Southwest Morrison Street between Sixth and Seventh (Broadway). By the end of the decade, the Elks neared one thousand members and began raising money to construct a permanent home of their own.[20] The lodge building opened to great fanfare on February 1, 1906, with an estimated two thousand people in attendance at the opening reception.

While the building was brick on its exterior, wood of all kinds dominated the interior spaces. Lounge rooms, hallways and the dining room included Craftsman-style box beam ceilings and wainscoting. The main lodge room included Ionic pilasters as well as brightly painted walls and ceiling. The Elks lodge also included a library and reading room, a billiard room and rooms

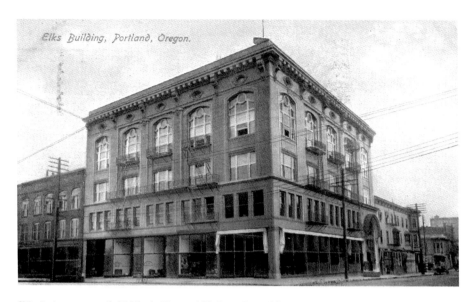

Elks lodge postcard, 1913. *Architectural Heritage Center Library*.

specifically set aside for women. The *Oregonian* described the new building as a "modern structure both in appointment and appearance."[21]

For all of the grandeur, the Elks only occupied two floors in the building. The second and fifth floors of the lodge building housed offices for rent, while storefronts occupied the first floor. It was common for fraternal lodge buildings in Portland to have plenty of rental space as a means of generating income and to help pay off any debt incurred during the building's construction.

The Elks' presence in Portland continued to grow; by the end of World War I, membership was approaching two thousand. In order to accommodate the size of their membership, the Elks decided to build a new and much larger building at Southwest Eleventh Avenue and Alder Street. The new Elks Temple opened at the end of 1923. By that time, the days of the old lodge were numbered. The building had already been sold to help pay for the new temple; plans were underway for an addition to the adjacent U.S. National Bank Building. In early 1924, demolition began on the Elks lodge. It was only eighteen years old. A representative of the demolition company noted how the materials being salvaged from the building were "almost new," adding, "It is a shame to pull it down."[22]

JOSEPH AND AUGUSTA DOLPH HOUSE

Said to have introduced the Queen Anne style to Portland, the Joseph and Augusta Dolph House stood on an entire city block bounded by Southwest Fifth and Sixth Avenues between Columbia and Jefferson Streets.[23] Architect Henry Cleaveland reportedly designed the house, which was built in 1881. Cleaveland, a San Francisco–based architect, was the designer of the Henry Failing House several years earlier. With the Dolph house, Cleaveland combined elements of Italian villas, like tall narrow windows and a prominent corner tower punctuating the roofline, with the asymmetry and ornamentation that was rapidly becoming popular on the West Coast at the time. The Queen Anne style would come to dominate residential architecture in Portland for the next two decades.

Joseph N. Dolph arrived in Portland in 1862, serving as Portland's city attorney and then as a U.S. district attorney before successfully entering politics as an Oregon state senator in 1866. That same year, he married Augusta Mulkey.[24] Less than two years after moving into their new house, Joseph Dolph successfully ran for the U.S. Senate. In 1883, he and Augusta moved to Washington, D.C., and Joseph's younger brother Cyrus moved

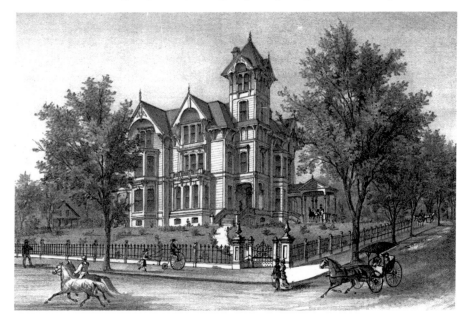

Joseph and Augusta Dolph House lithograph, *West Shore Magazine*, June 1, 1882. *Norm Gholston Collection.*

into the almost new house with his family. After losing his reelection bid in 1894, Joseph and Augusta returned to Portland. Upon their return, Cyrus Dolph purchased the Isaac Jacobs house on the South Park Blocks, where his family lived until the late 1930s. Meanwhile, only two years after returning to Portland, Joseph Dolph died. Augusta moved out of the house almost immediately; the original owners of this grand mansion lived in the house for only a handful of years.

With eight bedrooms and other rooms measuring upward of fifty feet in length, the house was perhaps the largest in the city when completed. The elaborately painted walls included portraits of Shakespeare and Goethe in the library. Furnishings in the house cost an estimated $100,000.[25] Given that the Dolphs spared no expense in building and furnishing their house, it seems odd that, by the early 1900s, it had become a boardinghouse.

In 1926, the house was summarily demolished. Its grandeur by that time had long been lost; the house, merely a block from City Hall, stood in the way of what many believed would be the continued expansion of the central business district. However, expansion was slow in coming. The full block upon which the Dolph House stood remained essentially vacant until the mid-1960s, when a Pietro Belluschi–designed bank building was constructed on the site.

PORTLAND HIGH SCHOOL

When the first public schools in Portland opened in the 1850s, there were no high schools. In fact, education beyond grammar school was typically only available through a private school, if it happened at all. This began to change in the 1860s as public school advocates clamored to give students the opportunity to continue on to college without having to attend one of the city's privately funded schools. The first public high school opened in 1869, sharing space in one of the local grammar schools, in what is now the Pearl District.

By the end of the 1870s, the Portland school district was seeking to build a new standalone public high school. It took several years to secure public funding and land for a new school. Finally, in 1883, construction began on the new high school along what is now Southwest Fourteenth Avenue between Morrison and Alder Streets. The architect of the school was William Stokes. Stokes had come to Portland from California, having

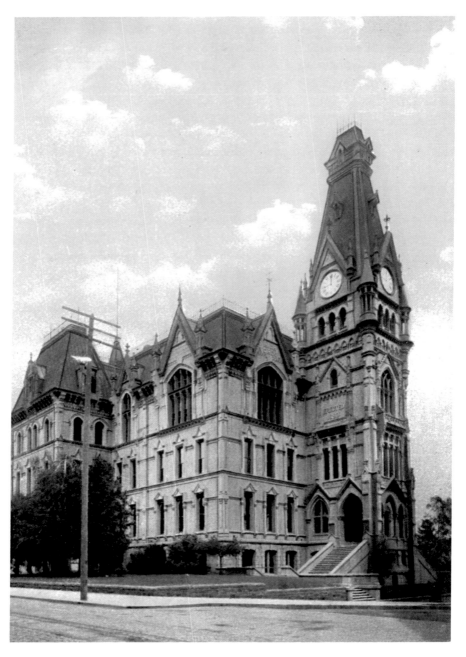

Portland High School postcard, prior to its renaming as Lincoln High School, circa 1908. *Architectural Heritage Center Library.*

designed buildings in both Oakland and Sacramento. He spent several years in Portland, later designing the heavily decorated Forbes House, another piece of Portland's lost architectural heritage, as well as the Goodnough Building that stood at Southwest Fifth and Yamhill, the present site of the Pioneer Place shopping mall.

At three stories, plus basement and tower, the 140-foot-by-200-foot school building was a marvel of its time, showing up prominently in images of the downtown area over the next several decades. Stokes adorned nearly every inch of the building's exterior. Were it not for the words "High School" emblazoned on the front-facing gable, it might have been mistaken for a Gothic cathedral. At the front entrance of the building stood a massive clock tower; oddly enough, the clock was never actually installed. Instead, clock faces were painted onto the building, including hands that always read 9:00! For a building that was otherwise so elaborate, this detail must have seemed quite peculiar.

Portland High School opened in 1885, but within a decade, it was reportedly already in need of major repairs. Inspectors questioned the building's safety, in part due to a sagging roof around the building's large central skylight. Stokes, who by that time had apparently returned to Oakland, responded to criticism of the building's condition, blaming it on the shrinkage of green lumber and on an overzealous school board bent on spending far more than was necessary.[26] Whether necessary or not, multiple repairs to the building were done over the next several years. When the East Side High School opened in southeast Portland in 1907, a new era of school building began; the old high school's days were numbered.

In 1909, the Portland High School was renamed Lincoln High School as the school district moved to rename the existing and soon-to-be-built high schools after Presidents Washington, Jefferson and Lincoln. Only three years later, a new Lincoln High School, built on the South Park Blocks at Market Street, replaced the aging original high school. The Girls' Polytechnic School (started around the time the old high school closed) soon moved into the former high school building, occupying it until 1928, with classes for young and adult women in subjects such as cooking, sewing and catering. The school's programs were designed both to create employment opportunities and to teach skills to stay-at-home mothers on topics like banking and letter writing.[27]

In 1928, the Girls' Polytechnic School relocated to a new building in northeast Portland. That school later became Monroe High School but now operates as the Da Vinci Arts Middle School. In late 1928, the old

Portland High School was demolished. By this time, the *Oregon Journal* newspaper had purchased the property and was considering building a new headquarters on the site. That project never came to fruition. With the onset of the Great Depression, followed by World War II, nothing was built on the site for many years. Finally, in 1956, a new bank building (still standing as of 2018, but no longer a bank) filled the empty lot where the old high school once stood.

MASONIC TEMPLE

At one time, the stretch of Southwest Third Avenue, on the west side of the street between Alder and Washington Streets, was one of the most frequently photographed blocks in the city. Numerous postcards from the first few decades of the twentieth century depict the block and its three architecturally distinct buildings—the Romanesque Dekum Building (built 1891–92), the Classical Revival Hamilton Building (1893) and the French Second Empire Masonic Temple (1871–72).

There were few large buildings west of Second Avenue in 1871, so it must have come as quite a shock to the many residents in the area when the Masons decided to build a new four-story temple at the northwest corner of Third and Alder. For the project, they hired the architectural firm of William W. Piper and Elwood M. Burton. Piper and Burton were both experienced Portland-area architects. Burton had been practicing in Portland since the 1850s. Piper was a little more restless. He had first come to Portland around 1864, working with Burton on the design of the Multnomah County Courthouse. He then left the city but returned a few years later and again collaborated with Burton, if only for a short while. Around the time they received the Masonic Temple job, they were also working on the New Market Theater, a building that still stands on Southwest First Avenue at Ankeny Street.

Formally dedicated on June 27, 1872, the building marked the beginning of Third Avenue as an important commercial thoroughfare. The building itself was also quite grand. Cast-iron columns framed the plate-glass windows and storefront entries on the ground floor. The second and third floors contained repeating pairs of windows and columns. At the top floor, dormers with pairs of round-arched windows topped with pediments extended from the mansard roof.

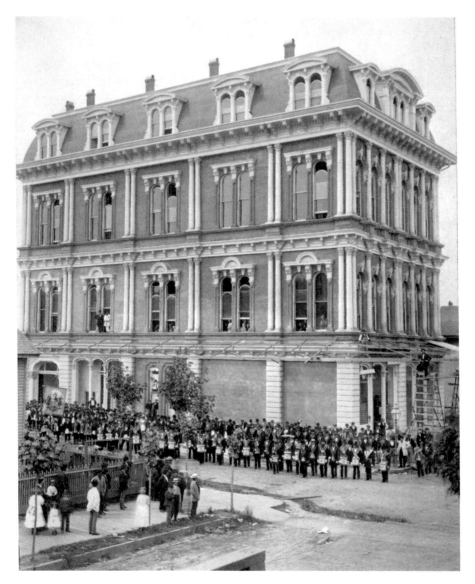

Masonic Temple, 1872. Photograph likely taken during the building's dedication ceremony. *Norm Gholston Collection.*

For thirty-five years, the temple served as meeting space for the Masons, Odd Fellows and other fraternal groups. In the years before the city had many dedicated auditoriums, the large meeting space also served as a venue for lectures, live theater and musical performances. In 1893, the Portland-

based book and stationery store J.K. Gill Company moved into the corner storefront. J.K. Gill had already been in business for more than twenty-five years and remained a prominent and growing business, eventually occupying the entire building.

Having outgrown their space in the temple, the Masons moved out in 1907 and into a new building located at Southwest Park and Yamhill Street. That building, known as the Pythian, is still standing. It actively served local Masons until they built a new temple on Southwest Park and Main Street in the mid-1920s. This Masonic Temple, also still standing, is now part of the Portland Art Museum.

The old Masonic Temple remained under ownership of the local Masonic Building Association until 1920, when it sold for $150,000, a price that was little more than what it had cost to build the temple in 1872. Within two years, the new owners were discussing plans to demolish the old building, replacing "one of the landmarks of the city" with a modern office and retail building.[28] J.K. Gill remained in the building until their new flagship store at Southwest Fifth and Stark was completed in 1923. Demolition of the temple seemed imminent, but building owner Isidore Holsman repeatedly changed his plans and did not move forward with the new building project for several years. In early 1928, demolition of the old Masonic Temple finally took place; immediately afterward, the twelve-story Loyalty Building was constructed on the site.

WOMEN OF WOODCRAFT LODGE

The Women of Woodcraft formed in Colorado in 1897 as an auxiliary of the Woodmen of the World, a fraternal organization that offered benefits, such as life insurance, to its members. Not long after forming, they split from the Woodmen and began offering similar services in nine western states, including Oregon. In order to strengthen the organization by having its administration in one location, the Women of Woodcraft relocated to Portland in 1905, setting up an office in a southeast Portland building near present-day Martin Luther King Jr. Boulevard and Morrison Street. They immediately began raising money for a new building of their own across the river in downtown.

In May 1905, the Women of Woodcraft purchased a quarter block property at the southeast corner of Southwest Tenth Avenue and Taylor

Street. Construction began on the new building in the summer of 1905, with Eric W. Hendricks as the architect. Hendricks is not a well-known Portland architect, but he later collaborated with Willard F. Tobey and John V. Bennes on projects such as the Cornelius Hotel, still standing at Southwest Park and Alder Street. The building itself was three stories tall, dropping to a single story at its eastern end along Taylor Street. Neoclassical in style, the stone exterior was fairly modest, with Ionic columns and a heavy cornice. At a glance, one might have guessed it was a government building but for the Women of Woodcraft frieze high above the Taylor Street entrance.

While providing life insurance and memorial benefits for its members, the Women of Woodcraft also played an important civic role in the city, bringing guest speakers to town to lecture on a variety of topics as varied as urban planning, spiritualism and even eugenics. In June 1912, advocates for woman suffrage used the kitchen at the Woodcraft building to make sandwiches and other food to sell on lunch wagons they drove around the city while seeking support for their cause.[29]

In 1917, the Women of Woodcraft renamed themselves the Neighbors of Woodcraft as a means of acknowledging that men had been significant

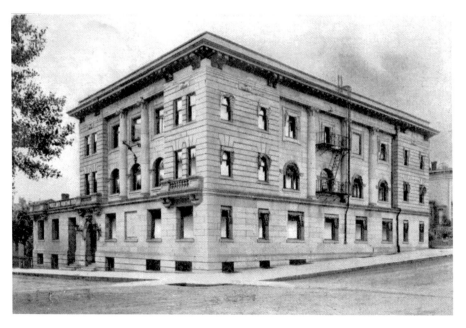

Women of Woodcraft Lodge postcard, circa 1910. *Architectural Heritage Center Library.*

supporters of the organization and their work. By this time, membership extended to men as well. That year, they also announced plans to build homes for members who were disabled or otherwise unable to care for themselves. The first such home opened in Riverside, California, in 1920.[30] By 1927, the Neighbors of Woodcraft sought to construct a new headquarters building at Southwest Fourteenth Avenue and Morrison Street. That building opened in July 1929 and is now listed in the National Register of Historic Places. Immediately upon moving into their new headquarters, the old hall at Southwest Tenth and Taylor Street was abandoned; within a year, it was demolished for a new parking lot and gas station. There is still a parking lot at that location today.

CHARLES AND SALLIE FORBES HOUSE

Located at Southwest Park Place and Vista Avenue, diagonally across the block from where St. Helens Hall once stood, the ornate Charles and Sallie Forbes House was an early twentieth-century Portland icon, frequently appearing on postcards depicting the city's residential neighborhoods.

Born in Iowa, Charles M. Forbes came to Portland in 1879 after having worked for a sewing machine company based in Stockton, California, for several years. Around 1881, Forbes collaborated with Edward C. Wheeler to start a furniture business that prospered even after Wheeler's death in June 1889. After Wheeler died, Forbes joined with the experienced furniture maker Henry C. Breeden. Their firm of Forbes and Breeden quickly became perhaps the city's most well-known purveyor of furniture, carpets and upholstery. Forbes was also active in local politics. From 1884 to 1893, he served on the Portland City Council, during a time in which the city underwent dramatic changes, including the further development of City Park (now Washington Park), the construction of a new City Hall and, perhaps most notably, the 1891 consolidation of Portland with the cities of East Portland and Albina.

In 1888, Charles Forbes married Sallie B. Bradbury; for a few years, the couple lived on Southwest Salmon Street near Seventh (Broadway). In 1891, they hired Portland architect William Stokes to design their new house. Stokes was best known in Portland for his design of the city's first stand-alone high school—a building that, like the Forbeses' house, would not survive the 1920s. Finished in early 1892, the couple's new house was one

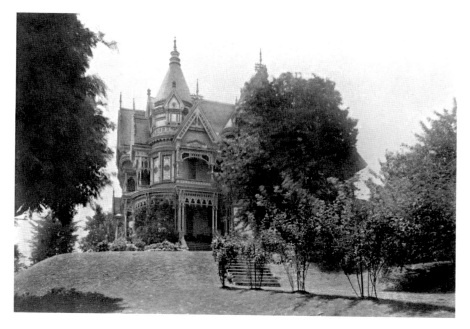

Charles and Sallie Forbes House, 1911. *Architectural Heritage Center Library.*

of the "handsomest" in their burgeoning hillside neighborhood.[31] Adorned with just about every type of architectural ornament one might imagine, the house was one of a kind. Decorative bargeboards and finials adorned each of the many gables and corner tower. Fine spindlework added to the exuberant exterior, as did a large Gothic front window surrounded by a quatrefoil in leaded glass. In many ways, the Forbes House was fitting for someone who dealt in fine furniture.

Unfortunately, Charles Forbes lived in the house for only three years before dying in 1895 at the relatively young age of forty-seven. Sallie Forbes moved out of the house soon after Charles's death. In 1897, the house sold to Henry W. Goode, then the general manager of Portland General Electric. The Goode family lived in the house until around 1902, at which time they sold the house to the owner of a local printing company named Graham Glass and his wife, Laura. Shortly after the Glass family moved out in 1929, the house was demolished. By that time, new apartment buildings were replacing many of the nearby older homes. The property where the Forbeses' house stood, however, remained vacant until construction of the Park Vista Apartments on the site in 1960.

3

1930–1949

Modernizing the City

The Great Depression brought about a new era of change to Portland, characterized by its emphasis on automobile accommodation and attempts at modernization. At the forefront of this period, the redevelopment of the waterfront, mostly in favor of moving vehicles through the city, led to the obliteration of an area that had once been so integral to Portland's success. In addition, property owners now found it more profitable to demolish some buildings and create parking lots rather than invest in building maintenance and repair. Buildings that had once been sources of great pride became scapegoats as the city faded from the glory of earlier decades.

The repurposing of older buildings added a temporary reprieve to many otherwise targeted for demolition. This included former schools converted during the 1930s intro vocational training facilities for adults. The few older homes that had survived years of downtown and near west side expansion did not last long once their prominent residents died or moved away. Meanwhile, the practice of stripping old commercial buildings to their framing turned many former landmarks into unrecognizable pseudo-modern structures. Such projects provided work for struggling architects and builders, but few created lasting value or even significant architectural interest.

HARRISON STREET SCHOOL

Located on Southwest Harrison Street between Fifth and Sixth Avenues, the Harrison Street School opened in January 1866 as the first new public school building in Portland since construction of the Central School a decade earlier. When it first opened, there were 160 students, but by the end of that school year, the number had more than doubled.[32] Enrollment continued to increase over the next decade as the surrounding area grew into a densely packed residential and commercial neighborhood. In May 1879, a fire destroyed much of the original school building. The school district rebuilt immediately using the original foundations. On September 6, 1887, fire again ripped through the school, this time displacing 640 students and necessitating yet another rebuilding effort.[33] Architect Otto Kleeman designed the new building. Kleeman is best known for his design of Portland's St. Patrick's Catholic Church, still standing in northwest Portland. The newly rebuilt school opened in January 1888. The building was of a design typical of the period: wood-framed with a central bell tower and separate entrances for the boys and girls. In 1904, the school district renamed Harrison Street School in honor of the late Judge Erasmus D. Shattuck. Shattuck was a former school board member and longtime resident of the neighborhood in which the school stood.

In the first two decades of the twentieth century, fire-related incidents in older wood-framed buildings led to a growing emphasis on fire safety, especially in public schools. With this in mind, in 1915, the Portland school district opened the new Shattuck School, a brick elementary school on Southwest Broadway. It served as a replacement for the aging Harrison Street School building. The district then rechristened the Harrison school building as the new Portland High School of Commerce. With a program focused on working in the business world, the school held courses for boys and girls in subjects such as bookkeeping, typewriting and economics. In 1930, the school district opened a new Commerce High School on Powell Boulevard in southeast Portland. That school is still in use, although it has since been renamed Cleveland High School. Within months of the 1930 opening of the new Commerce High School, the old Harrison Street School was demolished. Portland State University's University Center Building now stands on the site of the Harrison Street School, and the 1915 Shattuck School is also part of the PSU campus.

View of South Portland looking east. Harrison Street School at center left, circa 1888. *Norm Gholston Collection.*

PORTLAND CHAMBER OF COMMERCE

In July 1890, an architect from Omaha, Nebraska, named Isaac Hodgson Jr. won the design competition for a new Portland Chamber of Commerce Building over local architectural firms including McCaw and Martin as well as Whidden and Lewis. Hodgson came from a family of architects and, prior to arriving in Portland, had collaborated with his father on projects in both Omaha and Minneapolis, Minnesota.

Hodgson's plans for the eight-story chamber of commerce building were selected not so much because of their architectural beauty but for the amount of rentable interior space he included in the design.[34] From the outset, the building project was on fragile ground financially. Its backers, led by a relative newcomer to Portland named George Markle Jr., recognized that in order to meet financial obligations, including a mortgage with the New York Life Insurance Company, they would need to rent every possible space inside the building. Even the tower that rose high above the central entrance became office space.

Located on the north side of Southwest Stark Street, the chamber of commerce building filled half a city block between Third and Fourth Avenues. After several delays and cost overruns, the building neared completion in

Chamber of Commerce Building postcard, circa 1905. *Architectural Heritage Center Library.*

the summer of 1893, just as Portland entered a brutal economic downturn caused by a much larger financial panic that began on the East Coast. Several local banks closed, among other events marking the end of what had been several years of continual and rapid growth in Portland. The building finally opened in September 1893.

Fresh off the chamber of commerce project, Multnomah County hired Hodgson to design a new courthouse, but as the economic crisis worsened, the county expressed dissatisfaction with the cost of his proposal, terminating the project altogether. A court battle ensued, as Hodgson sought payment for his design services. He soon lost that battle, and given the economic uncertainty of other major projects in Portland at the time, Hodgson sold his house, closed his architectural office and returned to the Midwest.

The financial upheaval in Portland ultimately led the New York Life Insurance Company to foreclose on the chamber of commerce building, thus beginning an era of absentee ownership.[35] In 1906, the building sold to the Spokane, Portland & Seattle Railroad. Only months after the railroad purchased the building, an enormous fire destroyed the structure's prominent tower. By this time, the local business community already thought the building was obsolete, even after repairs to fix the extensive fire damage.

Over the years, the building served as home to banks, bars and a variety of offices, including those of several Portland architects. Hodgson himself had an office in the building when it first opened. However, the building never seemed to be very profitable. In the early 1930s, as Portland was once again in the midst of economic woes, the building owners elected to create a half block of automobile parking by demolishing the once prominent landmark. In the summer of 1934, demolition began on the forty-year-old chamber of commerce building. Nearly eighty-five years later, the site is still a parking lot.

WASHINGTON BUILDING

Architect Henry J. Hefty was at the height of his career in 1889 when he designed the exuberant Washington Building, located at the southeast corner of Southwest Fourth Avenue and Washington Street. Hefty would soon go on to design St. Helens Hall (1890–91) and, in 1891, began work on a new city hall before being fired from that project.

Built in 1889, the Washington Building was one of the most unique designs to ever grace downtown. The brick and stone building was five stories in height and replete with architectural decoration. As Hefty would do with St. Helens Hall a couple of years later, he began with what was, more or less, a Romanesque building, with large round arched windows and entryways. But after that, Hefty showed no modesty whatsoever. Elaborate details like

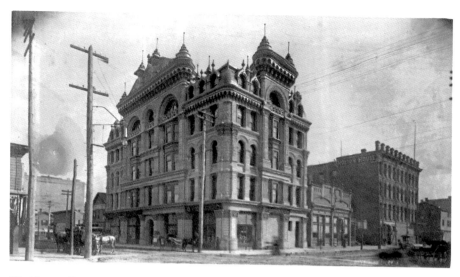

Washington Building, circa 1890. *Norm Gholston Collection.*

trios and quartets of columns framed the upper-story window openings. The machicolated cornice supported fanciful swan's neck pediments hiding a mansard roof. Finials abounded, some giving the appearance of cherry-topped whipped cream. In all, the building was not unlike some of the Queen Anne houses constructed around the same time.

The initial owners of the building were Edward Holman and William Fliedner. Holman was the most prominent undertaker in the Portland area; the business started in 1854 and is still around as of 2018. Fliedner was a barber by trade, a member of the Portland City Council and, like Holman, by the 1880s, a real estate investor. The Fliedner Building, still standing at Southwest Tenth and Washington, was one of William Fliedner's later investments. Perhaps not coincidentally, Fliedner was on the Portland City Council when Henry Hefty was chosen to design the city hall.

The Washington Building housed numerous retail businesses and offices over the years, but by the end of the 1920s, it was considered outdated. In 1931, the building was almost demolished for a new six-story structure, but that project never materialized, and the Washington Building held on a few more years. The year 1935 marks the true end of the Washington Building's life. That summer, a project to modernize the building led to the removal of the four upper floors and all of the ornate exterior architectural details. A new second floor was added to the building, with horizontal windows providing a Streamline Moderne appearance.[36] In 1936, local

real estate sales mogul Frank L. McGuire purchased the newly remodeled building and renamed it the McGuire Building, moving his staff of fifty realtors out of the aging Abington Building, where he had been since the early 1920s.

The two-story McGuire Building housed the real estate company until the early 1960s, by which time Frank L. McGuire had other offices around the Portland area. In 1964, the building sold to Melvin Mark Properties, which demolished the building and others on the western half of the block to make way for a multistory parking garage with room for five hundred cars and street-level retail storefronts.

HENRY AND EMMA CORBETT HOUSE

Built in 1874, the Henry and Emma Corbett House was for several decades one of a pair of landmark houses located just south of the Pioneer Courthouse on blocks between Fifth and Sixth Avenues—the other being the Henry Failing House.

Henry W. Corbett came to Portland in 1851, eventually becoming one of the young city's most powerful business and political leaders, serving as a senator from Oregon between 1866 and 1872. Like many early Portland settlers, Corbett began his career as a merchant, parlaying his profits into investments in everything from wheat to transportation while also constructing several commercial buildings.

Designed by architect Warren H. Williams, the Corbett house property occupied the entire city block bounded by Taylor and Yamhill Streets. The house was designed using a blend of French Second Empire and Italianate styles, both of which were popular in 1870s Portland. On the front (Fifth Avenue) side of the house, an arched gable roof was unique among Portland houses, as was the curved porch. The narrow round arched windows displayed architect Williams's predilection for the Italianate style. On the interior, there was exquisite detailing, from stenciled walls to frescoed ceilings, topped off by the Corbetts' extensive collection of art.

Henry Corbett died in 1903, but Emma continued to live in the house for more than thirty years. In the early 1920s, the Corbetts' grandsons, who by this time controlled the family's finances, sold the northern half of the block. On what had been a lawn and a garden rose the Albert E. Doyle–designed Pacific Building, completed in 1926. Doyle designed an attic apartment in

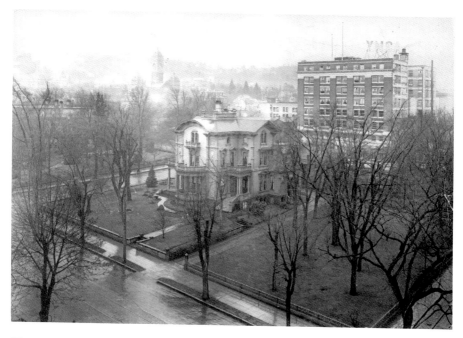

Henry and Emma Corbett House, circa 1910. *Norm Gholston Collection.*

the Pacific Building for the aging Emma Corbett, but she refused to move from her house, and the space was put to other uses.[37]

In July 1936, Emma Corbett died. Within a few months, the family sold the house; in October 1936, it was demolished. At the time of the demolition, a representative for the company doing the work noted, "This is one of the best-constructed houses I have seen in years."[38] A new bus depot, constructed where the house once stood, opened in 1938. The depot was demolished in 2000 to make way for a new hotel. The Pacific Building still stands on the block and faces the Pioneer Courthouse. It was listed in the National Register of Historic Places in 1992.

HIBERNIAN BUILDING

Founded in 1830s New York City, the Ancient Order of Hibernians is an Irish Catholic fraternal organization created to support Irish immigrants facing discrimination or those in need of social services or employment.[39]

The Portland chapter was founded in 1877, holding its meetings in a building at Southwest First Avenue and Stark Street. A little more than a decade later, their membership had grown to the point that the Hibernians decided to build their own facility.

In 1889, the Hibernians hired the architectural firm McCaw and Martin to design their new building at Southwest Sixth and Washington. At the time, McCaw and Martin was easily one of the city's most prestigious architectural firms; McCaw had recently completed work on the First Presbyterian Church on Southwest Twelfth. That building remains a downtown landmark to this day. McCaw and Martin was also soon to become the firm most well known in Portland for its 1890s Romanesque-style buildings. Nevertheless, after McCaw and Martin submitted a full set of plans for the project, the Hibernians decided to employ another local firm instead. McCaw and Martin sued the Hibernians for lack of payment for their services rendered. Meanwhile, the Hibernians hired the firm of David L. Williams and his uncle Franklin Williams to complete the project.[40]

Although not known for Romanesque designs, Williams and Williams drew up plans for the building that exemplified the style, considered quite modern for its time. Completed in 1891, the Hibernian Building cost around $50,000 (approximately $1.3 million in 2018). The Hibernians occupied the third floor with offices and meeting rooms while renting the second floor to a variety of dentists, doctors and other professional service providers. A principal financier of the building, the Union Banking Company, occupied the main floor.

A mere two years after the building opened, its future as home to the Hibernians was already in doubt. In the summer of 1893, the Union Banking Company became a casualty of the nationwide financial panic that hit Portland particularly hard. The bank went into receivership, but the Hibernians were able to remain in the building until 1902, at which time they moved to a new location. In 1907, the Merchants Savings and Trust Company acquired the building, renaming it the Merchants' Trust Building. It owned the building until 1929, during which time it added two floors and removed the original Chateau-like roofline. The building changed hands twice more in the ensuing decade before men's clothier Joe Weiner purchased it in 1939.

During the Great Depression, Portland-area architects suffered through a lack of work designing new buildings. Those that did find consistent work often found themselves hired to design remodels of existing buildings. After Joe Weiner purchased the Hibernian Building, he hired the architectural

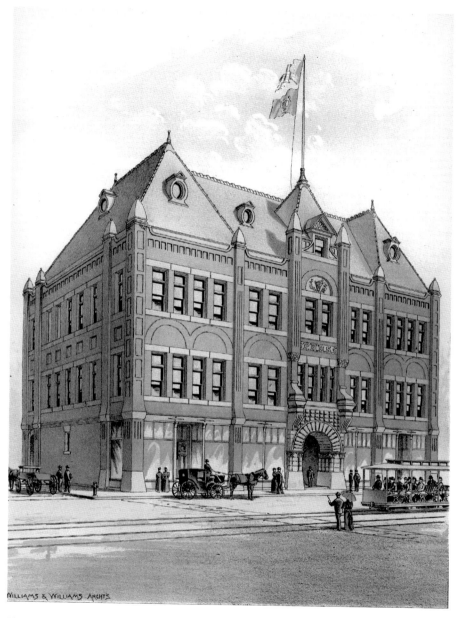

Hibernian Building lithograph, *West Shore Magazine*, September 13, 1890. *Architectural Heritage Center Library.*

firm A.E. Doyle and Associates, led at the time by Pietro Belluschi, to design a remodel of the entire building.[41] Belluschi completely transformed the building from Romanesque, with round arches, along with plenty of brick and stone, to Streamline Moderne, with bands of horizontal windows and an exterior re-clad with marble panels. A few years later, Belluschi would design the Equitable Building (now known as the Commonwealth) directly across Washington Street from Weiner's store. The Commonwealth Building is famous as one of the first glass and aluminum high-rise office buildings erected in the United States after the end of World War II.[42]

Weiner's remained in business through the 1960s, even after the death of Joe Weiner. In 1969, the store merged with Seattle-based Prager, another men's clothing store. This merger was short-lived; the store closed altogether in 1971, after which time the building languished with a variety of tenants. In the mid-1990s, a large parking garage with ground-floor and basement-level retail stores replaced the Hibernian/Weiner's Building.

STEPHENS SCHOOL

Twentieth-century warehouse and industrial buildings line Southeast Seventh Avenue today, belying the fact that the area between Grand and Eleventh Avenues once contained a thriving neighborhood filled with houses, churches and schools. A few houses remain, but most have been converted into other uses as the area has long been designated part of the Central Eastside Industrial District. Other traces of the neighborhood are scattered and difficult to find or have been long since erased. Such is the case with Stephens School, an elementary school that once stood on the block bounded by Southeast Seventh and Eighth Avenues, and Harrison and Stephens Streets.

Named for the founder of the city of East Portland, James B. Stephens, the school was located in the southern portion of Stephens' Donation Land Claim, an area that extended between the Willamette River, Twentieth Avenue, Division Street and Stark Street. The first Stephens School was built around 1878. After a fire destroyed that building in November 1889, the East Portland School Board hired architect Thomas J. Jones to design a new building on the same site. Like most of the public schools in town at the time, Jones designed the wood-framed schoolhouse with a central entrance topped by a bell tower. Decoration was modest for the time but still included

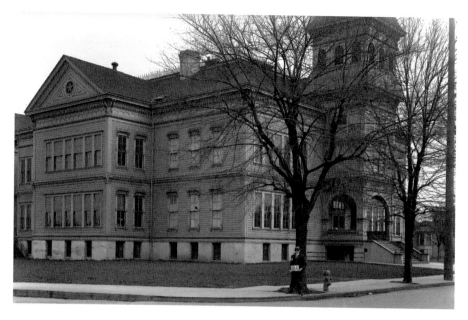

Stephens School, 1929. *City of Portland (OR) Archives, A2009-009.330.*

flourishes like pairs of decorative wooden brackets, dentils just beneath the roofline and iron cresting on the rooftop. The new Stephens School opened in 1890. T.J. Jones, as he was commonly referred to, eventually became the Portland school district's first official architect. In 1920, son George H. Jones also became the school district's architect, following in his father's footsteps. Almost all of the schools designed by T.J. Jones are now gone, but many of the more than two dozen Portland-area schools designed by George Jones are still standing as of 2018.

The neighborhood around the school began to change to a more industrial area as early as the 1910s; by the end of the 1920s, many of the older homes were gone. In 1926, Abernethy School opened several blocks to the east in the much more residential Ladd's Addition. With the opening of Abernethy School, Stephens School no longer served elementary students but continued to serve the community in an educational role. The Works Progress Administration sponsored a variety of adult education courses at the school throughout the 1930s on topics such as auto mechanics, heating and ventilation, algebra and basket making.

In December 1938, the Portland school board voted to demolish the school as soon as possible. Classes relocated to other locations around the

city; by October 1939, the old building was empty. Demolition began a few months later. For several decades, Portland General Electric has operated an electrical substation filling two adjoining city blocks, including the one where the school once stood.

FRONT AVENUE

Front Avenue (now Naito Parkway) is the street where Portland was born. At one time, it was the center of commerce in the young city, and it has long served as an important north–south thoroughfare. Whereas today the river side of the street contains a seawall and Tom McCall Waterfront Park, from the 1870s until the early 1940s, more than two dozen commercial buildings stood along that side of Front Avenue, between about Southwest Madison and Northwest Davis Streets. Many of the buildings along the river side of Front Avenue were adjacent to wharves dating to the city's earliest days. Businesses that operated out of these buildings therefore had a direct connection to the river, making it easy so send and receive goods such as furniture, lumber, liquor and clothing.

On the west side of Front Avenue, wood-framed buildings appeared in the 1840s. In 1853, Absalom B. Hallock designed and built the first brick building in the city on behalf of William S. Ladd. Located on the west side of Front Avenue between Southwest Washington and Stark Streets, Ladd ran his liquor and wine business out of the building before hiring Hallock to add a second floor, which became the first home of the Ladd and Tilton Bank.[43] Other brick buildings soon appeared, many adorned with an ever-increasing amount of cast-iron architectural decoration.

In December 1872, and then again in August 1873, devastating fires destroyed more than twenty blocks of early Portland buildings, most of which were all-wood construction, including some along the waterfront. New brick and iron buildings began to fill the burned-out blocks, some as tall as five stories in height and decorated with cast iron, carved wood and a variety of stamped metal ornamentation. By the end of the 1880s, Front Avenue was lined on both sides with a variety of colonnaded buildings, creating the appearance of a European city. The street was at its commercial and architectural zenith.

Repeated Willamette River floods, especially one in June 1894, took their toll on the buildings nearest the river—not just from flood damage, but

also because the floods encouraged downtown developers to look farther away from the river for new opportunities. Architectural tastes also began to change in the 1890s, with less interest on extraneous decoration and more emphasis on the structures themselves. By the turn of the twentieth century, many of the retail shops had moved west to Third Avenue and beyond. Front and First Avenues became the heart of what was then called the city's "Wholesale District," still supplying local shops with goods, but it was no longer the place where people went to shop. By the end of the First World War, the streets between the river and Second Avenue, and especially Front Avenue, remained architecturally interesting, albeit with faded commercial relevance.

The erosion of Front Avenue as an important commercial area was further impacted with construction of a seawall along the river between the Hawthorne and Steel Bridges. Completed in 1929, the seawall reduced the likelihood of flooding along Front and other streets near the river, but its construction led to the removal of the wharves that had once played such an important role in the area's success. Construction of the seawall also included a major sewer project, designed in part to prevent sewage backups

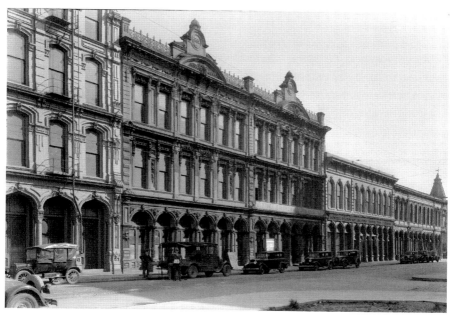

East side of Southwest Front Avenue (Naito Parkway), between Ankeny and Ash Streets. *Left to right*: Dodd Block (1888), Cook Block (1882), Ankeny & Watson Building (1868) and Central Block (1879), circa 1930. *City of Portland (OR) Archives, A2009-009.2495.*

into the basements of the buildings along Front Avenue and adjacent streets. The sewer project reportedly "undermined" at least one building near the waterfront, leading to its demolition.[44] The demolition of the three-story Bank of British Columbia building, located on a triangular property bordered by Front Avenue, First Avenue, Ankeny and Vine Streets, coupled with the loss of the wharves, added to the already growing sense that Front Avenue lacked economic viability.

With the onset of the Great Depression, Front Avenue was in dire straits. Financing for building repairs and maintenance was limited, leading to widespread disinvestment. As a result, property owners began leaving the upper floors of their grand buildings vacant, or mostly so. Secondhand shops and a variety of painters, plumbers and similar building contractors now operated out of the once prominent storefronts. Hoping to rejuvenate at least part of the waterfront, a new Public Market was built just north of the Hawthorne Bridge, opening at the end of 1933. By 1935, the Portland City Council was considering a proposal to reinvent Front Avenue, connecting the newly constructed Barbur Boulevard at the southern end of downtown with Harbor Drive, a new road to be built atop the seawall. This proposal addressed motor vehicle traffic while also providing a narrow park near the waterfront. The plan clearly targeted the buildings lining the east side of Front Avenue for demolition. After several years of discussion, the Harbor Drive plan began to take shape in 1939, thanks to support from the local office of the Works Progress Administration. With federal and state money available, the cost to the City to redevelop Front Avenue would be minimal. A public vote in May 1940 approved the funding of the so-called Front Avenue Improvement Project. Almost immediately, demolition began on some of the grandest buildings ever to grace the streets of Portland; by the summer of 1942, they were gone.

Three decades later, Harbor Drive was itself declared no longer necessary, and in 1973, highway officials closed the roadway in conjunction with the opening of the Fremont Bridge connecting Interstate 405 with Interstate 5. Opening in 1978, Tom McCall Waterfront Park integrated the little-used strip of parkland between Front Avenue and Harbor Drive, creating a park that filled the entire area between Front Avenue and the river.

Meanwhile, the west side of Front Avenue has endured dramatic changes as well. Most of the early buildings were destroyed between the 1930s and the 1950s. Construction of bridge ramps to the new Morrison Bridge in the mid-1950s led to the demolition of three full blocks of these early structures. William S. Ladd's 1853 brick building, the once glorious Kamm Block, and

a host of other cast-iron decorated buildings, all stood along the west side of Front where today only a few stragglers remain. One of the survivors is the heavily altered Hallock and McMillan Building from 1857, at Southwest Naito Parkway and Oak Street. It is purported to be the oldest standing commercial building in the city, and there is hope that one day the building will be restored to its 1850s appearance.

WITCH HAZEL BUILDING

Van B. DeLashmutt was once one of Portland's wealthiest citizens. By the 1880s, he owned property all around the city. He served as president of the Oregon National Bank, which he had cofounded in 1888, the same year he was appointed mayor of Portland. He also owned mines in Idaho as well as a streetcar company. However, perhaps his most prized possession was his farm, near Hillsboro, where he raised and bred horses. The Witch Hazel Farm became the namesake of DeLashmutt's new building when construction began in 1892.

Finished in mid-1893, the Witch Hazel Building stood near the western approach to the Madison Street Bridge, which had opened in 1891. It was one of the more peculiar buildings to ever grace downtown Portland. The four-story building adhered to the dominant Romanesque Revival style of the early 1890s, with heavy stone arched entryways at the ground floor and similar arches in brick over the top-floor windows. However, the Witch Hazel's corner turret made the building unique among its many peers. It extended from the second floor to well above the building's rooftop, with each floor providing a bay window for the occupants. The turret extended above the main building's roofline but was solid brick, with no lookout and a conical roof. In some ways, it gave the building the appearance of a medieval castle. The architect for the building remains unknown, although Henry J. Hefty is a good candidate, due to the frequent inclusion of turrets in his building designs.

Some buildings seem doomed to fail from the outset, and the Witch Hazel falls into this category. Just as work was wrapping up on the new building, the economy began to falter. In July 1893, the Oregon National Bank was forced to close, starting a chain of economic losses for DeLashmutt.[45] Not long after the Witch Hazel Building's exterior was completed, he lost it to foreclosure. By 1894, rooms in the building's upper floors were available to rent, but it

Minor White, *Witch Hazel Building and the Hawthorne Bridge*, 1940. *bb015335, Oregon Historical Society Research Library. Commissioned by the Works Progress Administration, public domain.*

appears that at least some of the building's interior remained unfinished. By the end of the decade, a feed store and coffee roaster operated out of the main floor storefronts, far less grand operations than what might have been expected of a building in such a prominent location.

Over the course of the ensuing decades, the Witch Hazel continued to operate as a rooming house with a variety of businesses operating out of the retail storefronts, including hardware stores, junk stores and paint and

plumbing supply stores. By the time the Hawthorne Bridge replaced the Madison Street Bridge in 1910, the building was no longer called the Witch Hazel. It was now known as the Ohio Hotel. From the mid-1910s until the building closed in 1941, the Sumida family ran the Ohio Hotel. Japanese immigrants, the Sumidas operated other similar hotels in Portland between the 1910s through the beginning of World War II.

After voters approved the Front Avenue Improvement Project in May 1940, the days were numbered for the Witch Hazel/Ohio Hotel and at least two dozen other buildings standing along Front Avenue. Demolition of the Witch Hazel and other nearby buildings began in June 1941. For more than forty-five years, the Witch Hazel Building had stood at the southeast corner of Southwest Front Avenue and Madison Street. The physical landscape of that location has so dramatically changed since the building's demolition that it is virtually impossible to imagine how that intersection once appeared.

WORCESTER BLOCK

After losing his reelection bid for the U.S. Senate in 1872, Henry W. Corbett returned to Portland and spent the last thirty years of his life investing in real estate and erecting new buildings, all while supporting the city's burgeoning cultural scene and social service organizations. At the end of the 1880s, Corbett embarked on several building projects. He led the team that finally brought the Portland Hotel to completion, followed by construction of the Worcester Block, the Neustadter Building at Southwest Fifth Avenue and Oak Street and, later, the still extant Hamilton Building on Southwest Third Avenue. Corbett supported the new Portland Library and the YMCA and was instrumental in the founding of the Portland Art Association, a predecessor to the Portland Art Museum, as well as the Boys and Girls Aid Society.

In 1889, work began on the Worcester Block, Corbett's new building at the northeast corner of Southwest Third and Oak Street—just across the street from the Ainsworth Block. Six stories in height, the new Worcester Block was an imposing edifice, but Corbett was not yet done. Two years later, he decided to build an identical building on the northern half of the block at Third Avenue and Pine Street, connecting the two structures in the middle and creating one of the largest office buildings in the city.

Built mostly of brick, covered with cement to give the appearance of stone and featuring heavy wood framing, Corbett's Worcester Block was not state-of-the-art construction at the time. By the early 1890s, so-called fireproof designs were fast becoming the norm. When completed in 1892, the Worcester was described as "slow burning," with nine-inch-thick floors, designed to slow a fire should one occur.[46] Red sandstone, similar to that used on the Oregonian Tower under construction at the same time, adorned the building's main entrance, which included a massive staircase extending to the sixth floor, as well as an early electric elevator.

The building housed dozens of offices and ground-floor businesses. In the 1890s, Charles Kohn's wholesale liquor business, one of the largest on the West Coast, occupied two full floors and the basement of the building's northern half.[47] There were offices for the Northern Pacific Railroad and the Oregon Railroad and Navigation Company. In the 1890s, several architects had their offices in the Worcester Block, including Edgar Lazarus, William Stokes and Frederick Manson White. It is possible that one of them was the architect of the Worcester Block itself, but that detail remains a mystery. From 1906 to 1926, Portland's most well-known architect of downtown buildings, Albert E. Doyle, had his offices in the Worcester Block.

Henry Corbett died in 1903, and his estate, run by his grandsons, maintained his buildings for many years. By 1920, the Worcester Block had lost much of its luster to the new and modern office buildings then filling up blocks to the south and west. With this in mind, the Corbett family sold the building. By the end of the 1920s, the variety of tenants had become less prominent and were geared toward construction businesses. Into the 1930s, some of the more interesting tenants included the Portland Chess Club, the well-known Oregon artist Henry Wentz, the Anti-Saloon League and the Women's Protective Division, an organization once led by Lola G. Baldwin, the first sworn policewoman in the United States. The Worcester Block was also home for many years to Oregon's Socialist Labor Party, which offered frequent talks with a variety of titles, including "War—Why?," "Who Pays the Taxes?" and "The Working Class: Its History and Mission." In early 1941, with the United States on the cusp of war, a clinic run out of the Worcester Block by the City of Portland encouraged prostitutes to get tested monthly for any signs of disease, showing more concern for the soldiers they might infect than the women themselves.[48]

In July 1941, the owners of the Worcester Block announced plans to demolish the building and erect a service station and parking lot on the property. Coming out of the Great Depression and with war on the horizon,

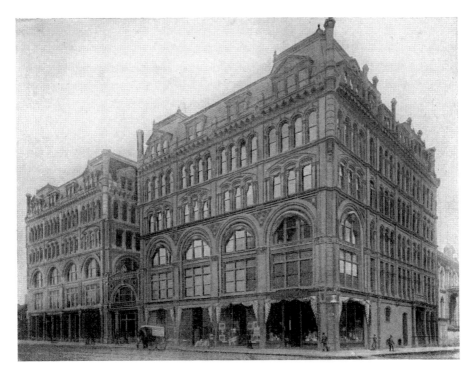

Worcester Block, 1892. *Architectural Heritage Center Library.*

it seems only natural that the company demolishing the building sold off much of the building material rather than haul it all off to a landfill. In one advertisement, the Dolan Wrecking Company offered a variety of Worcester Block building parts for sale, including two million bricks, five hundred washbasins and several thousand feet of linoleum.[49] Demolition began in September 1941, but the parking lot and service station along Third Avenue never came to fruition. Instead, a new city jail was built on the lot in 1945, as well as a parking garage along the Pine Street end of the block, between Second and Third Avenues. The police headquarters, located at Second Avenue and Oak Street, had been a neighbor to the Worcester Block for decades, so construction of a jail perhaps came as no surprise. In 1983, a new Downtown Justice Center opened, at which time the jail, too, was deemed obsolete. After years of limited use, it was demolished. The 1940s parking garage still occupies the northern half of the block, while the corner at Third Avenue and Oak Street, where the first section of the Worcester Block and later the jail once stood, remains vacant as of 2018.

JACOBS FAMILY HOUSES

When strolling Portland's South Park blocks, it is difficult to imagine that the stately homes of some of the city's most prominent citizens once lined the streets adjacent to the park. Most of those houses were gone by the early 1930s; among the last to be demolished were the twin homes of brothers Ralph and Isaac Jacobs.

Ralph and Isaac Jacobs were the founders of Oregon City Woolen Mills, a company that earned the brothers a significant fortune. In the early 1880s, the wealthy brothers hired Portland's most prominent architect, Warren H. Williams, to design a pair of nearly identical houses along the South Park Blocks. When completed in 1882, the two houses filled the block along the west side of what is now Park Avenue between Montgomery and Mill Streets. The houses were elaborately ornamented with features typical of the Italianate style, including bracketed cornices, Corinthian columns and two-story bay windows. Both houses had a central entrance leading to dramatic circular staircases with frescoed ceilings and domed skylights.

The Ralph Jacobs family resided in the southernmost of the two houses until around 1939. In December 1940, it was the first of the two to be demolished. Meanwhile, Isaac Jacobs had sold his house to prominent Portland attorney Cyrus A. Dolph back in 1895. Cyrus Dolph was the younger brother of noted Oregon senator Joseph Dolph. The Dolph family lived in the house until around 1940. Just a few weeks before the Jacobs-Dolph House was demolished, the Portland Art Museum hired Minor White to photograph the entire house. White's images of the Jacobs-Dolph House as well as those of the Knapp House in northwest Portland serve as some of the best documentation of the grandeur in which the prominent citizens of late nineteenth-century Portland lived.

Knowing that the house was to be demolished, members of the Dolph family salvaged pieces of the beautiful interior woodwork, including columns, paneling and doorway pediments. Several decades later, the Bosco-Milligan Foundation, owner of the Architectural Heritage Center in southeast Portland, acquired much of this salvaged woodwork.

By the early 1940s, apartment buildings stood where many of the former residences along the South Park Blocks had once been. In the case of the full block where the Jacobs brothers' houses stood, that block remained empty until well after the end of World War II. In 1950, the X-shaped Ione Plaza apartment tower was built on the site. The Ione Plaza has since been renamed the Vue Apartments.

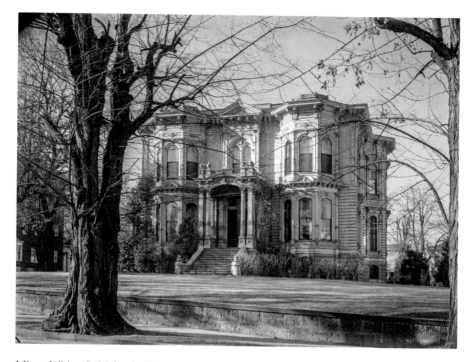

Minor White, *Ralph Jacobs House*, 1938. *bb015328, Oregon Historical Society Research Library.*
Commissioned by the Works Progress Administration, public domain.

Offering a glimpse of what the street may have looked like more than a century ago, the magnificently restored Simon Benson House occupies a corner lot at the intersection of Southwest Montgomery Street and Park Avenue, across the street from where the Jacobs brothers' houses once stood. The Simon Benson House was moved to this location in 2000 after languishing for many years a few blocks away at Southwest Eleventh Avenue and Clay Street.

HILL MILITARY ACADEMY

In 1901, the longtime head of Portland's Bishop Scott Academy, Joseph W. Hill, decided to open a new school for boys with military-type discipline but without the ties to a religious order that the other private schools in Portland maintained. Hill enlisted the help of architect Joseph Jacobberger to design

his new school on Northwest Marshall Street between Twenty-Fourth and Twenty-Fifth Avenues. Neighbors were not happy with Hill's decision to build the school in the midst of a residential area, but Hill persisted; the school opened that September.

The four-story school resembled a fortress in some ways, with a crenellated tower and roofline, but it was also unique for its "slow burning construction."[50] Architect Joseph Jacobberger designed the school with heavy wooden planks lining the inner walls rather than using the more traditional lath and plaster. The outer walls also had a layer of heavy wooden planks, but wooden shingles gave the building a finished appearance similar to houses of that era. A one-inch layer of sand between each of the floors in the building served as another tool against a potential spreading fire.

Hill Military Academy sports teams excelled on the field, often competing against university squads in basketball and baseball. Several graduates of the school went on to become prominent military officers as well as politicians. Robert S. Farrell Jr. was one such graduate. After attending the school, he went to law school at the University of Washington before becoming a prominent Portland attorney. In 1938, he was elected to the Oregon State House of Representatives and in 1943 became Oregon's secretary of state. Tragically, he died in a 1947 plane crash along with Governor Earl Snell and state senate president Marshall E. Cornett.

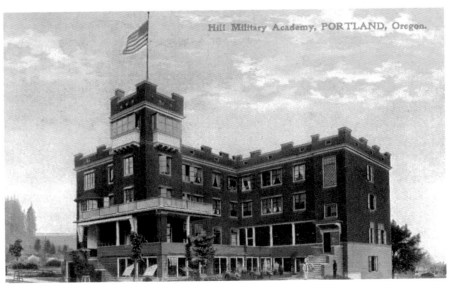

Hill Military Academy, 1910. *Architectural Heritage Center Library.*

In 1931, Hill Military Academy moved across town to a new campus on Rocky Butte.[51] The school operated at that location until closing in 1959. In the meantime, the school used the old location as an annex for a few years before leaving it essentially abandoned by the early 1940s. In the summer of 1943, neighbors upset by the dilapidated building and the reported rats and transients occupying it petitioned the Portland City Council to condemn the building.[52] After months of delay by building owner James A. Hill, son of the school's founder, the city council adopted the condemnation order, and the building was soon demolished. In 1948, a one-story office building was constructed on the site.

KAMM BLOCK

In 1883, Jacob Kamm hired architect Justus F. Krumbein to design a building for his property on Southwest Pine Street that extended from Front (now Naito Parkway) to First Avenue. Construction started in the summer of 1884, and the building was finished the next year. The Kamm Block became a testament to Kamm's status in the city, where he had risen from steamboat captain to become co-owner of the Oregon Steam Navigation Company and, as a result, one of Portland's wealthiest denizens.

The Kamm Block was arguably the grandest of all the cast-iron decorated buildings in Portland. At four stories in height, plus a central tower that extended another sixty feet above the roof, the building quite literally towered above its neighbors. Adorning the building was a conspicuous blend of ornament, including cast-iron details like pilasters featuring winged griffins and a colonnade along its Front Avenue side. Hand-carved wooden Atlas-like figures supported a balcony over the building's main entrance on Pine Street, complemented by similarly carved female figures high above, but just below the main entrance pediment.[53] The Kamm Block set the stage for the rest of the 1880s commercial buildings erected along Front Avenue, many of them also designed by Krumbein. This included the 1888 Dodd Block, which featured similar ornamentation to the Kamm Block, albeit on a building of about half the size.

Among the early occupants of the Kamm Block was the Portland office of the fledgling U.S. Weather Bureau. At 125 feet above street level, the building's tower served as a perfect location for taking temperature and other weather readings. Other tenants included the Northern Pacific

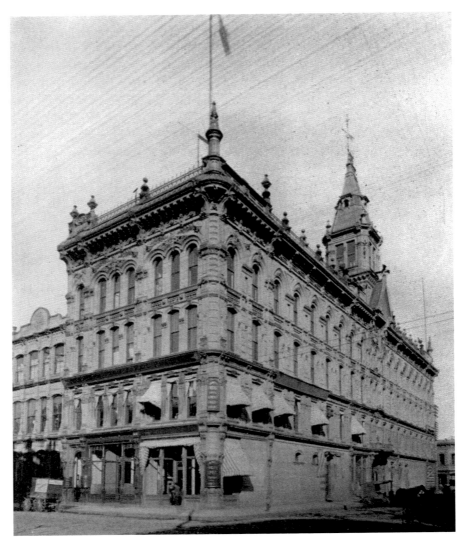

Kamm Block, 1892. *Architectural Heritage Center Library.*

Railroad Company and the U.S. National Bank of Portland (now U.S. Bank). In early October 1892, fire swept through the upper floors of the building, killing two men, including a firefighter struck by falling debris when the tower collapsed.

After the blaze, Jacob Kamm decided against rebuilding the tower. The four-story, two-hundred-foot-long building remained one of the largest in

the city, but as with much late nineteenth-century architecture, the Kamm Block was soon viewed as outdated. Already by the early 1890s, years of repeated Willamette River flooding was taking its toll on the buildings along and near the waterfront. Businesses began to move farther west, away from the flood zone and into new style buildings with far less ornament and more emphasis on structure. As with many of the buildings in the area, the Kamm Block began to suffer from neglect.

Jacob Kamm died in 1912, not long after selling some of his real estate holdings in Portland for the construction of Lincoln High School on the South Park Blocks. That building is now Lincoln Hall on the campus of Portland State University. Portland Public Schools would later purchase the property on which Kamm's house stood, near Southwest Fourteenth Avenue and Salmon Street, building a new Lincoln High School in 1951. Meanwhile, the Kamm Block continued to fade from the public mind as new buildings filled the downtown streets west of Fourth Avenue. By the onset of the Great Depression and the start of the 1930s, the Kamm Block, like many of the oldest downtown buildings, was dilapidated and underutilized. The general lack of investment near the waterfront, coupled with a growing interest in redeveloping Front Avenue in particular, spelled the end for many of the Kamm Block's neighboring buildings. Then, in September 1939, a major fire ripped through the eastern half of the Kamm Block, leaving it a burned-out shell. The fire-damaged half of the building was taken down the following year. Perhaps as a testament to how much people appreciated the building for its architectural beauty, the virtually unoccupied western half of the Kamm Block remained standing until 1949, at which time a local parking lot developer purchased the building and property.[54] There has been a parking lot on the former site of the Kamm Block ever since.

NAHUM AND MARTHA KING HOUSE

The Amos and Matilda King family were Oregon Trail pioneers, arriving in the Oregon Country around 1845 before coming to Portland around 1849. They operated a tannery along a creek that ran through the area now covered by Providence Park while also investing in land in and around the Portland area. Amos and Matilda's son Nahum A. King started his working career in southern Oregon, raising the horses used to pull streetcars back in Portland. After returning to the city, he began managing the family's

Nahum and Martha King House, 1911. *Architectural Heritage Center Library.*

real estate holdings in the area. In 1908, after years of financial success, he and his wife, Martha, built a new house on land the King family had originally platted at the northwest corner of Southwest Twentieth Avenue and Salmon Street.

King hired the architecture firm Emil Schacht and Son to design the new house. Well-known in Portland for his residential designs, Emil Schacht also designed the Lenox Hotel in downtown (another lost Portland building) among hundreds of projects he completed during a Portland architectural career lasting more than twenty years. The King house represented the Colonial Revival style at its finest—or at least its most elaborate. Built on an east-facing slope, the house had an enormous wraparound porch and balconies providing views over the city and farther east toward the Cascades. The front section of the porch alone was seventy-five feet long and fifteen feet deep. Supporting the balconies were trios of Ionic columns, themselves supported by a massive brick foundation. The interior of the house included five bedrooms, five bathrooms, a library, a billiard room, an elevator and an art glass ceiling above the grand staircase between the first and second floors.[55] When completed, the house cost an estimated $40,000 (more than $1,000,000 in 2018).

Nahum and Martha King lived in the house until around 1926. Newspaper advertisements in the late 1920s and early 1930s offered furnished rooms for rent in the house. It even served as a polling center during early 1930s elections. Martha died in March 1930, and Nahum passed away only a few months later. The house stood until the end of the 1940s, when the property sold for redevelopment, one of the first tall apartment towers built in Portland after the Second World War. The Portland Towers, built in 1950–51, still occupy the site of the King house, while the neighboring King's Hill Historic District pays homage to the pioneering King family on a portion of the land they once owned.

4

1950–1967

Displacement and Destruction

Entering the 1950s, Portland's central city remained stagnant, as it had for most of the previous two decades. People were moving farther away and relying less on downtown services. The belief that making it easier for people to drive into downtown, and around the city in general, would remedy the situation outweighed any concerns voiced over the loss of landmark buildings and entire neighborhoods. In the 1950s, Portland got its first taste of Urban Renewal and freeway building, whereby swaths of the city were so physically changed they became unrecognizable. Little attention was given to the thousands of displaced residents, let alone the socially and culturally significant buildings in these neighborhoods.

The period from 1950 to 1967 saw the loss of architecturally or historically significant houses and buildings like no other era before or perhaps since. Iconic buildings that had once been the center of attention in Portland were razed with no expectation of worthy replacement. Out of this destruction arose the sensibility that if buildings were not going to be saved, maybe their parts could be. Such attitudes eventually led to the formation of an organized historic preservation movement in the late 1960s.

In the midst of all of the intentional demolition, a massive fire destroyed one of the most beloved landmarks in the city, removing the last traces of the famous exposition that once put Portland on the map.

OREGONIAN TOWER

Another of the large Romanesque Revival buildings that once dominated the downtown Portland skyline, the Oregonian Tower literally took the city to new heights, with its clock tower rising high above the one-hundred-foot-square, nine-story building. Located on the northwest corner of Southwest Sixth Avenue and Alder Street, the clock tower brought the building to a total height of nearly two hundred feet, making it the tallest in the city, a record it held for more than a decade after its completion in 1892. Designed by the San Francisco architecture firm the Reid Brothers, the Oregonian Tower was the first of several building projects the company designed in Portland. It later returned to design the Yeon Building (1911) and Jackson Tower (1912), both of which still stand.

In an age just prior to the widespread use of reinforced concrete, the Oregonian Tower was billed as "absolutely fireproof." Terra-cotta encased all of the iron and steel framework supporting the main structure.[56] As with other Romanesque buildings, the exterior was not adorned with the type of extraneous ornament that defined Portland buildings from previous decades. Rather, decoration was subtler and classically influenced. Sandstone gave the lower floors of the building's exterior a sturdy appearance. Entryways included elaborately carved round-arched openings. The upper floors of the building were brick, at the time still the most often used commercial building material. Aside from carvings in the sandstone, decoration was mostly via hand-molded terra-cotta panels with floral designs. While the building's height made it stand out among its peers, the new edifice also complemented a growing commercial district that included the nearby Marquam Building and Portland Hotel.

The *Oregonian* newspaper was founded in 1850, only two months before Portland was incorporated as a city. By the 1890s, owner Henry L. Pittock and editor Harvey W. Scott had created the most widely read newspaper in the state.[57] The newspaper continued to grow, even after the deaths of Scott in 1910 and Pittock in 1919, at which point their heirs continued to operate it. In 1922, KGW radio, founded by the *Oregonian*, began broadcasting from the clock tower and continued to do so until 1943, when a fire in the studio forced it to relocate.[58] In 1948, the building was sold and the *Oregonian* moved into a new facility on Southwest Broadway and Columbia Street designed by Pietro Belluschi. That July, the iconic tower clock was stopped as the new owners, Los Angeles–based Store Properties Incorporated, contemplated repurposing the building. The old building

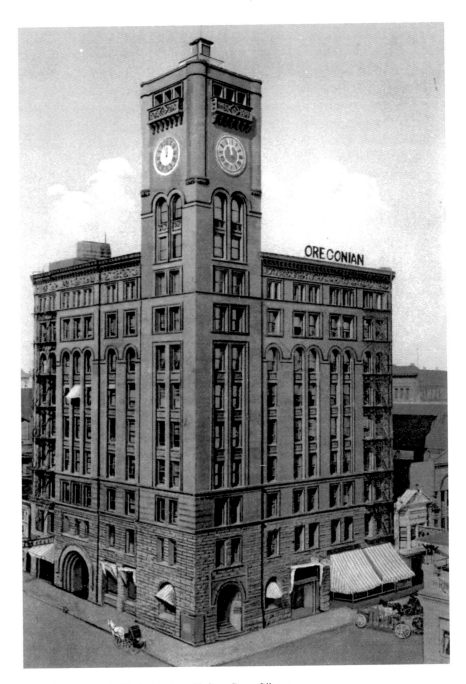

Oregonian Tower, 1910. *Architectural Heritage Center Library.*

remained empty, and in January 1950, after a large piece of terra-cotta fell from the ninth floor and hit a car, the city initiated condemnation proceedings. With pressure from the city and with the iconic building now viewed as a public safety hazard, the owners decided demolition was their only option.[59]

The demolition of the Oregonian Tower began in May 1950 and continued into the fall. By the time the newspaper celebrated its one-hundredth anniversary on December 4, 1950, all traces of its former headquarters were gone. The end of an era along Sixth Avenue came only months later, when the Portland Hotel was also demolished, leaving none of the grand brick and Romanesque buildings from the 1890s. The demolition of the Oregonian Tower was also perhaps a sign of the times, economically, for downtown Portland. There were few large downtown buildings constructed over the next decade. A much smaller structure replaced the nine-story Oregonian Tower. Then, in the 1990s, a massive, ten-story parking garage with retail storefronts was built on the site.

RICHARD AND MINNIE KNAPP HOUSE

Within a few years of arriving in Oregon in 1859, Richard B. Knapp became the principal owner of Knapp, Burrell and Company, a successful agricultural equipment business started by his brother Jabez several years earlier. With outlets in Oregon and Washington, Knapp soon became one of Portland's wealthiest citizens.

In 1882, Knapp hired architect Warren H. Williams to design a new house. Williams was in the middle of a short-lived career in which he designed some of the city's most important buildings, including twin houses on the South Park Blocks for brothers Ralph and Isaac Jacobs and Beth Israel Synagogue. Williams also designed the still extant Calvary Presbyterian Church, now known as the Old Church, as well as Villard Hall at the University of Oregon in Eugene. He was the initial architect for the famous Craigdarroch Castle in Victoria, British Columbia. He died in early 1888 before the Beth Israel or the Craigdarroch project was completed.

Williams engaged William F. McCaw to supervise construction of the Knapp house. McCaw would later design Portland's First Presbyterian Church (1889), and his firm of McCaw and Martin would design several Portland buildings in the 1890s, including the Dekum. Located at the corner

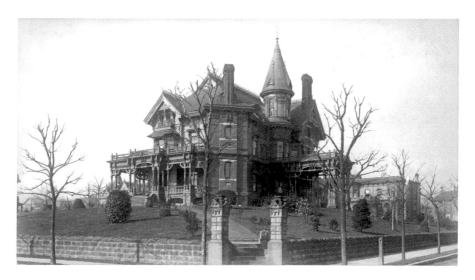

Richard B. Knapp House, circa 1892. *Norm Gholston Collection.*

of Southwest Third Avenue and Washington Street, the Dekum remains one of the city's most beloved historic buildings.

The house took nearly three years to build, and Richard and his wife, Minnie, did not move in until the fall of 1885. The Knapp house reportedly cost nearly $90,000 to build (roughly $2 million in 2018).[60] Located on the block bordered by Northwest Davis and Everett Streets between Seventeenth and Eighteenth Avenues, the Knapp house was an immediate city landmark. From the front porch to the tower, both inside and out, the Knapp house displayed the highest quality craftsmanship available in 1880s Portland. A variety of hardwoods lined the interior walls, floors and ceilings, in everything from walnut to ebony. Ornate stained glass added even more elegance to the main entry doors and elsewhere, including in the curved tower windows. The exterior included turned wooden columns, spindle work and first- and second-floor windows located in the center of a massive corner chimney.

Unfortunately, Richard Knapp, like so many other Portlanders, lost much of his fortune in the 1893 economic panic; he lost the house to foreclosure in 1897. Subsequent occupants of the house included Parker F. Morey, the president of Portland General Electric, and his family. Morey and his wife, Clara, had both been widowed in previous marriages. They leased the house for several years, raising their combined nine children, supported by four servants and two gardeners.[61] Richard Wilson, a retired silver miner

from Spokane, purchased the house for only $65,000 in 1901.[62] The house remained in the Wilson family after his death in 1913. A descendant of Wilson's, Lucilla Lindley, and her husband, Joseph, later inherited the house and lived there until early 1951.

The Lindleys sold the house to St. Mary's Catholic Parish, which announced plans in the spring of 1951 to demolish the structure and build a new playground on the property. That June, hundreds of Portlanders filed through the house as guided tours led by the Portland Art Museum provided one last look at perhaps the most ornate house ever built in the city. But this story doesn't end with the house being completely bulldozed and sent off to a landfill. Eric Ladd, one of Portland's historic preservation pioneers, contracted with the church to sell off much of the hardware, millwork, windows, light fixtures, fireplaces and just about every architectural element imaginable. As a result, pieces of the Knapp house made their way into countless other Portland-area houses. Demolition of the Richard and Minnie Knapp House began in the summer of 1951. The site has been a parking lot since that time, a stone wall the only remnant of what once stood there.

PORTLAND HOTEL

The loss of no other building in Portland has been so lamented as that of the Portland Hotel. From its storied and much delayed construction to its demise, the building has captured the imagination of city residents for more than a century.

The construction of the hotel began in 1883 and was the brainchild of financier Henry Villard. Villard led efforts to connect Portland with the rest of the United States through his Northern Pacific Railroad. Dissatisfied with existing hotels in the city, and knowing the railroad would soon arrive, Villard acquired the full city block where the Central School stood and began planning his new hotel. To design the building, Villard hired an up-and-coming New York architectural firm, McKim, Mead & White. Charles McKim had first come to Portland with Villard in 1881, around the time his firm was still working on Villard's new palace-like Manhattan mansion.[63] McKim's design for the five-story hotel was reminiscent of a French chateau, significantly different from other Portland-area buildings under construction at the time. Construction of the hotel began in mid-1883 under the supervision of William M. Whidden, an architect from the McKim, Mead

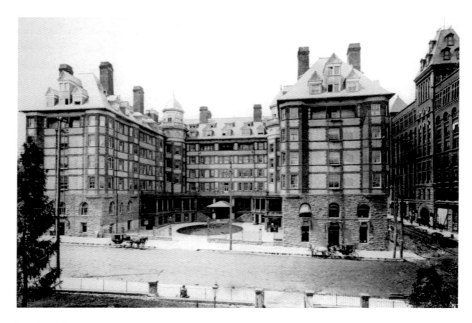

Portland Hotel, 1903. *Architectural Heritage Center Library.*

& White office. Within months, however, the hotel project was in trouble. Villard's financing for his railroad and related projects, including the hotel, collapsed in December 1883. The project came to an abrupt halt with stone foundations for the lower floors of the hotel the only thing standing. William Whidden returned to New York, and the building site was left as a partially constructed ruin.

Four years later, a consortium of local investors led by Henry W. Corbett and Henry Failing revived the hotel project. Forming the Portland Hotel Company, they acquired the hotel property and once again hired William Whidden to oversee completion of the building. In April 1890, the Portland Hotel finally opened. In bringing the hotel to fruition, Whidden made few, if any, design changes to the original McKim, Mead & White plans. To be certain, the Portland Hotel was an instant landmark. At five stories tall and filling an entire two-hundred-foot-square block, the building was massive, if not imposing. In the early 1890s, new and sometimes larger commercial buildings were beginning to appear on blocks near the hotel, all part of the westward expansion of downtown. Many of these new buildings, including the Marquam, directly across the street on Morrison Street, were of a more modern architectural style for the time—Romanesque Revival. This meant

that the Portland Hotel, once at the cutting edge in both design and physical presence, was, within a few years of opening, no longer so.

For all its faults, some of the most notable visitors to Portland between the time of its opening to the onset of the Second World War stayed at the Portland Hotel. This included Presidents Theodore Roosevelt, Woodrow Wilson and Herbert Hoover. Samuel Clemens famously stayed at the hotel in 1895 while performing as Mark Twain at the nearby Marquam Grand Opera House. Conventions and trade shows hosted by the hotel included those for grocers and automobile, radio and hardware dealers. Perhaps more significantly, the hotel served as a center of city life, hosting countless social functions for area residents. Among the events frequently held at the hotel were weddings, dances, banquets and reunions for local and national organizations. It was perhaps in this way that the hotel built a reputation as more than just a palace for the wealthy.

After the 1905 Lewis and Clark Exposition spurred nearly a decade of citywide economic growth, the owners of the Portland Hotel considered constructing a massive addition to the building. In 1910, architect Albert E. Doyle drafted rough plans for a twelve-story addition to rise from the hotel's center courtyard. Postcards showed the addition as if it was already there, but the project never materialized. By this time, new hotels like the Benson, Congress and Multnomah were beginning to spring up all over the downtown area, creating worrisome competition along with more modern facilities. The Portland Hotel's glory days were over. By 1925, there was talk of tearing the hotel down and replacing it with something much larger. By the end of the decade, however, Portland's growth had dramatically slowed and, along with it, any immediate intentions to demolish the building. Although plans were occasionally floated, no large commercial buildings would be constructed in downtown until after the end of the Second World War.

In 1944, the Meier and Frank department store purchased the hotel. At the time, Meier and Frank was near the pinnacle of its success, having grown from a small storefront near the river in the 1850s to operating a flagship store that filled an entire city block in the heart of downtown. The growing presence of the automobile led Meier and Frank to consider ways to provide customer parking, and the fading hotel, kitty-corner to the store, presented the opportunity.

After continuing to operate the Portland Hotel for several years, in June 1951, Meier and Frank president Aaron M. Frank announced plans to close and demolish the venerable landmark. Frank asserted that the initial plans were to replace the hotel with a two-level parking garage and eventually

a much larger commercial building. The months-long demolition of the Portland Hotel began that August; by the spring of 1952, the parking garage opened with space for more than four hundred cars. Perhaps trying to maintain the sense of community that people felt about the old hotel, Meier and Frank set up one thousand chairs on the lower level of the parking garage, along with dozens of new television sets, so that area residents could come watch the 1952 Democratic Presidential Convention.

Throughout the next two decades, the parking garage endured; Meier and Frank never did move forward with a new downtown building. Finally, in the 1970s, as the city implemented a new plan to revitalize downtown, the parking lot became expendable. The city sought to make the area more inviting to tourists and residents from around the area, thereby reenergizing the downtown business district. At the heart of this effort was the creation of a public square. The construction of Pioneer Courthouse Square on the site of the parking garage—where the Portland Hotel once stood—remains a signature moment in the city's history. On the Sixth Avenue side of the square stands a section of iron gate from the lost hotel.

AINSWORTH BLOCK

Captain John C. Ainsworth came to Portland in the early 1850s, piloting steamboats on the Willamette River and becoming one of the principals in the Oregon Steam Navigation Company, making him one of the wealthiest men in the young city. In the 1860s, Ainsworth had a house built on Southwest Third Avenue between Pine and Ash Streets. At that time, Third Avenue was on the outskirts of downtown and the Ainsworth House was prominent among the residences in the area.

Having transported goods between Portland and San Francisco for many years, Ainsworth developed close business ties in California. It was, therefore, perhaps no surprise when, in 1881, he hired a California-based architect to design a new commercial building rather than choosing one of the more than a dozen local architects practicing in the city at that time.

Architect Clinton Day came from a prominent Bay Area family. His father cofounded the school that became the University of California at Berkley. Clinton Day later designed buildings for that school as well as for Stanford University. In Portland, he designed the Ainsworth Block at the northwest corner of Southwest Third Avenue and Oak Street, just a block

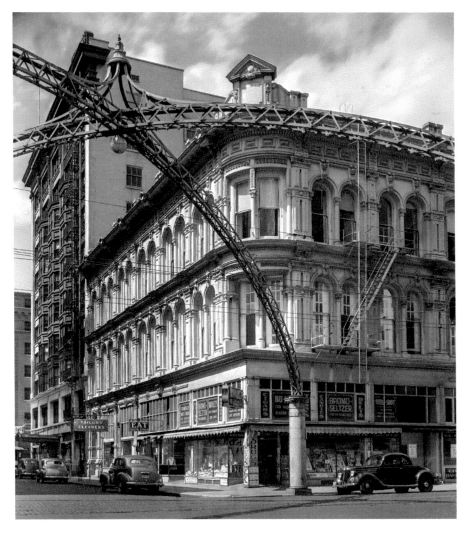

Minor White, *Ainsworth Block*, 1939. *bb013227, Oregon Historical Society Research Library.*
Commissioned by the Works Progress Administration, public domain.

from Ainsworth's house. A year later, Day returned to Portland, designing the First National Bank just a few blocks away. Both the Ainsworth Block and First National Bank had prominent and decorative cast-iron exteriors; both have sadly been lost.

Upon the building's completion, the Ainsworth Block became home to the newly formed Ainsworth Bank, created by two families—John C. Ainsworth

along with son George J., and brothers Luther L. and William J. Hawkins. Within two years, the bank expanded into the Ainsworth National Bank, and in 1902, the bank merged with another local bank, thereby creating the predecessor of the U.S. National Bank (U.S. Bank) that still exists to this day. The bank continued to operate from the Ainsworth Block until moving to a brand new building on Southwest Sixth Avenue and Stark Street in 1917.[64] In 1907, the British consulate's office moved into the Ainsworth Block, but after the U.S. National Bank left, the building faced uncertain times. By the 1930s, the building housed a mixture of residents, artists and musicians, along with a pharmacy and a lunch counter.

In early June 1955, a local parking garage operator named Kadderly and Morton announced plans to demolish the Ainsworth Block in order to create additional parking spaces. Kadderly and Morton already owned most of the city block on which the building stood, including a parking garage at the northwest corner of the block built in the 1920s. Ainsworth's old house had been moved to that site many years earlier and was subsequently demolished. In August 1955, the Ainsworth Block was demolished. More than sixty years later, the corner on which the building once stood is still a surface parking lot.

McMILLEN'S ADDITION AND LOWER ALBINA

At the east end of the Broadway Bridge, Northeast Broadway bisects an area that at one time was a thriving and long-established residential neighborhood. To the north, most of the area is now industrial or highway land, while to the south is the city's Rose Quarter, the location of the Veterans Memorial Coliseum and the Moda Center (originally the Rose Garden) arena. Interstate 5 to the east and railroad tracks and the river to the west hem in the area and have left few clues as to its rich history.

In 1865, James H. McMillen purchased forty acres on the east bank of the Willamette River. McMillen's property, known as McMillen's Addition, included much of what is today the Rose Quarter. The McMillen family house overlooked the river, near where the Louis-Dreyfus grain elevator facility is presently located, just north of the Steel Bridge. By 1900, McMillen's Addition was dotted with single-family residences. To the north of McMillen's property, the Irving family and others had begun to develop their properties around the same time. Houses eventually filled the area west

Aerial view of the Willamette River and Broadway Bridge, 1948. McMillen's Addition and Lower Albina are at center right. *City of Portland (OR) Archives, A2005-005.1394.5.*

of Wheeler Avenue and south of Hancock Street. Just slightly north of this area, at Russell Street, was the heart of the original townsite of Albina, but as that area grew and eventually incorporated as a city in 1887, it enveloped both sides of Broadway and was often referred to as Lower Albina.

The proximity to rail yards made McMillen's Addition and Lower Albina ideal for working-class residents, but the neighborhood also served as a melting pot of longtime Portlanders, newcomers and immigrants. Around 1906, Portland architect Justus Krumbein, his wife, Christine, and their family moved from northwest Portland to the corner of McMillen Street and Wheeler Avenue. The well-known Chinese merchant Seid Back lived only a few blocks away at McMillen and Larrabee Avenue.

From the 1910s onward, the neighborhood began to receive an influx of African Americans. Most were relocating from the vicinity of Union Station in northwest Portland, where there were fewer and fewer housing options. In 1912, the congregation of the Bethel African Methodist Episcopal Church moved from downtown to a new facility at the intersection of McMillen and Larrabee Avenue in the heart of McMillen's Addition. Months later, the Broadway Bridge opened, creating a direct connection

between McMillen's Addition, Lower Albina and the west-side rail yards that employed many of its residents.

As Portland grew, it became increasingly difficult for African Americans to purchase property or even find decent rental housing. White residents frequently complained when Africans Americans moved into otherwise all-white neighborhoods. Under the guidance of the Portland Realty Board, real estate agents refused to sell houses to African Americans outside of a narrow strip of the city's east side that included the onetime city of Albina, Lower Albina and McMillen's Addition. By the 1920s, this area was the center of Portland's African American community.[65]

The onset of the Second World War brought several thousand African Americans to Portland for work in local shipyards while doing little to mitigate ongoing segregation in the city. Lower Albina and the adjacent McMillen's Addition remained one of a limited number of neighborhoods in which these newcomers could find housing. Company housing built by the shipbuilding Kaiser Corporation as well as public housing in new developments like Columbia Villa in far north Portland offered some options, but these were limited and often not intended as permanent structures. Once the war was over, African Americans continued living in what had been temporary wartime housing at Vanport and elsewhere. But after a flood wiped out Vanport in 1948, McMillen's Addition and Lower Albina absorbed many of the displaced residents.

In the 1950s, Portland began to explore the possibilities of Urban Renewal while also seeking to build a new exposition and recreation center that included a large arena. In March 1957, after a lengthy and controversial decision-making process, McMillen's Addition and the section of Lower Albina south of Broadway were chosen as the site for (Veterans) Memorial Coliseum. The neighborhood, in which many African American residents of the city had been forced to live, was swept away from them as the city quickly began acquiring property for the coliseum. Once again, African Americans were forced to find housing in the few parts of town that would accept them. The congregation of Bethel African Methodist Episcopal Church relocated to Northeast Eighth Avenue, where they built a new facility. By the end of 1957, demolition of McMillen's Addition had begun; the coliseum site was clear of almost all the old buildings within months. The (Veterans) Memorial Coliseum opened in November 1960 and remains an architectural landmark in the city.

Some houses and buildings survived the initial demolition for the coliseum, including the former home of the McMillen family, which stood

until construction began on the Thunderbird Motel in 1959. In 2002, Portland Trailblazer owner Paul Allen had the motel demolished; the site remains a parking lot as of 2018. Near the south side of Broadway, a few other buildings survived the initial construction of the coliseum but have long since been demolished. Construction of Interstate 5, just to the east of McMillen's Addition, and the 1990s construction of the Rose Garden Arena further removed traces of the once thriving neighborhood. To the north of Broadway, houses still covered most of the blocks of Lower Albina between Larrabee and Wheeler Avenues until the mid-1970s, when Portland Public Schools acquired much of the land and built a massive new educational service center.

JULIUS AND BERTHA LOEWENBERG HOUSE

Prussian-born Julius Loewenberg arrived in Portland in the mid-1850s. A series of successful business ventures, including a longtime metalwork business in partnership with Philip Goldsmith, meant that by the 1880s Loewenberg was one of the city's wealthiest residents. By this time, he was pursuing additional business interests, including those in banking, finance and insurance. As president of the Merchants National Bank, Loewenberg sustained not only great wealth but also prestige. With this in mind, he chose to locate a massive new family home high above downtown, at the end of Southwest Park Place, next to the entrance to City Park (now Washington Park). Loewenberg enlisted architect Isaac Hodgson Jr. to design the thirty-two-room house in 1891. It would turn out to be one of the few Romanesque Revival stone houses ever constructed in Portland.

As work began on the Loewenberg house, Hodgson was on the verge of becoming Portland's most sought-after architect. Among his projects was the ill-fated Portland Chamber of Commerce Building, designed in 1890 and still under construction. For the Loewenbergs, Hodgson designed a three-story house with round arches and heavy stone columns adorning the front entrance as well as upper-floor balconies. A glass-enclosed conservatory extended from the south side of the house, as did a porte cochere. At the east end, a tower with an enclosed balcony offered views of the city and the Cascade Range far beyond.

The 1890s were turbulent economic times in Portland. In 1893, just months after the house was completed, the Merchants National Bank

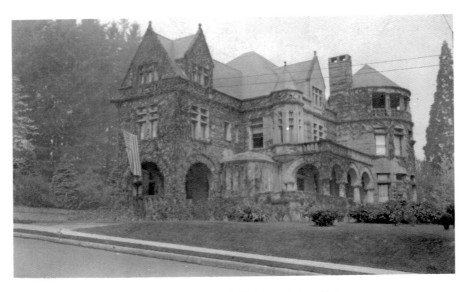

Julius and Bertha Loewenberg House, circa 1905. *Norm Gholston Collection*.

nearly failed, forcing Loewenberg to use his own funds to keep the bank afloat.[66] The bank's near failure was followed by a series of lawsuits related to Loewenberg's other business ventures, which by that time included a woodstove foundry at the Oregon State Penitentiary in Salem. Julius Loewenberg died in October 1899, forcing his widow, Bertha, and their four children to sell off family possessions—and ultimately their grand hillside mansion—in order to pay off legal debts.

In 1902, Frederick W. Leadbetter bought the Loewenberg house. Leadbetter was a wealthy lumber and paper mill owner. The Leadbetter family lived in the house for the next forty-five years. After Frederick Leadbetter died in 1948, his widow donated the house to the Oregon Historical Society, which considered turning it into its headquarters and museum. When those plans were determined to be unfeasible, OHS sold the house to a real estate investment firm, eventually using the proceeds to acquire land on Portland's South Park Blocks, where it built a new facility that is still in use. After being rented out for a few years to a group of bachelors, in 1958, the Loewenberg house was left vacant. Demolition took place in the spring of 1960, and a new apartment complex was built on the site.

PERKINS HOTEL

Born in England, Richard S. Perkins arrived in Portland in 1852, running a butcher shop for a decade before turning toward raising cattle and sheep. By the 1870s, he had a farm in the Beaverton, Oregon area as well as herds of thousands of cattle in eastern Oregon. In the 1880s, he decided to give up the cattle business, returning to Portland, where he ventured into the hotel industry as operator of the Holton House, a well-respected downtown establishment.[67] In 1889, Perkins decided to build his own hotel and hired architect Justus F. Krumbein to design it.

Located on the northeast corner of Southwest Fifth Avenue and Washington Street, the Perkins Hotel opened to the public on February 4, 1891. At six stories, the building was not the tallest of the new structures being built in the city at that time. Nevertheless, Krumbein and Perkins's collaboration made the hotel into an instant landmark. Built of brick, iron and stone, the one-hundred-foot-square building was topped at the corner by a steeply roofed tower with an alcove containing a hand-carved cedar steer, painted gold. This was Perkins's way of celebrating how he had made his fortune. Beyond the corner tower, the exterior of the hotel was a unique blend of vaguely Romanesque and Italianate details. Rather than the heavy stone base of typical Romanesque Revival buildings of the time, Krumbein's design included a ground floor that was a toned-down version of his 1880s commercial buildings. Cast-iron pilasters still framed windows and doorways, but gone were the extraneous ornaments found on other Krumbein projects like the Dodd Block on Front Avenue finished only a couple of years earlier. Oriel windows added texture to the design, as did round-arched windows at the fourth floor. An arcade-style cornice added yet another flourish. The Gilbert Building (1893), still standing at Southwest Third Avenue and Taylor Street, was another project from the Krumbein office and contains a similar arcade-like detail. On the interior, the building was notable for the inclusion of electric lighting and the use of local woods, especially in the furnishings. The Portland-based Oregon Furniture Manufacturing Company built most of the hotel's original furniture.[68]

Perkins, like so many others in 1890s Portland, fell into serious financial difficulty following the economic panic of 1893. In 1896, he lost the hotel to foreclosure. Richard Perkins died in 1902. Lot Q. Swetland purchased the hotel in 1907, remodeling the building and changing its name to the "New Perkins." The famous steer was removed for many years before Swetland returned it to its tower alcove in 1924. In the 1940s, the hotel was renamed

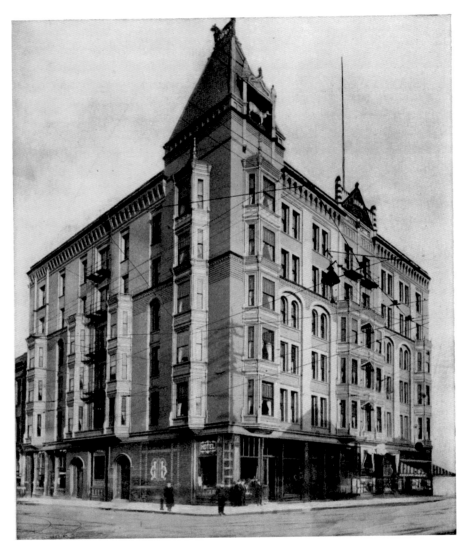

Perkins Hotel, 1905. *Architectural Heritage Center Library.*

the Milner for a few years before being sold again in 1948, at which time the Perkins name returned.

As early as the mid-1890s, critics of the Perkins Hotel thought the location better suited for other commercial uses; by the mid-1950s, that fact was certain. In 1956, the Portland Savings and Loan Association purchased the hotel and shut it down permanently the following year, loaning the famous

steer to the nearby Lipman's department store for display in its men's clothing section. Demolition of the hotel occurred in September 1961, and a modern bank building was erected on the site, completed in 1963. As of this writing, the bank building faces an uncertain future. In 1979, the famous steer that graced the building's tower was donated to the Oregon Historical Society.

FORESTRY BUILDING

The Lewis and Clark Centennial Exposition grounds were in far northwest Portland, near the present site of the Montgomery Park complex. In 1904, a young architect working for the well-known Portland firm of Whidden and Lewis was tasked with designing one of the exposition's few permanent buildings. Albert E. Doyle soon became one of Portland's most important architects; it was his plans for the exposition's Forestry Building that marked the beginning of a brilliant career.

Almost all of the buildings that were part of the exposition were temporary structures built in the Spanish Renaissance style. The Forestry Building, however, was altogether different. With the trunks of old-growth fir trees (their bark intact) used as interior columns, and to create an exterior colonnade, the Forestry Building was at once a log cabin, a Greek temple and a cathedral. The building measured 102 feet by 206 feet and, for the exposition, was filled with a variety of displays, including wildlife dioramas and exhibits of forestry products showing off the bountiful Northwest forests.[69]

The exposition created a tremendous boom for the city, but after it ended, most of the buildings faced demolition, dismantling or relocation. Exposition organizers gave the Forestry Building to the City of Portland in 1906 as exhibit space. In 1907, the first Portland Rose Festival included displays in the Forestry Building. Time took its toll, and by the 1920s, the building was in need of repair. In 1925, the City closed off the interior balconies because many of the wooden supports had begun to deteriorate or warp. Already acknowledged as a city landmark, the Forestry Building was by that time one of only a few surviving structures from the exposition. But, even with such public interest in the building, the city undertook few repairs. With the onset of the Great Depression, followed by World War II, the building continued to languish in the shadow of an ever-growing industrial area while still serving a useful purpose as a meeting and exhibition hall.

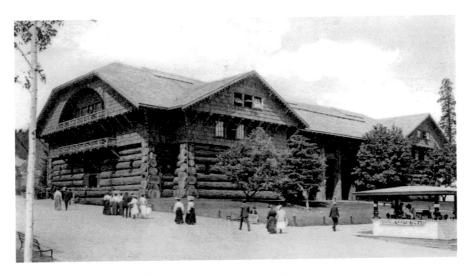

Forestry Building, circa 1907. *Architectural Heritage Center Library.*

In 1948, the City, with support from the Portland Chamber of Commerce, embarked on several years of repairs, culminating in the 1952 reopening of the building with all new exhibits dedicated to the wood-products industry. Throughout the next decade, the building served as one of Portland's most popular tourist attractions.

On the evening of August 17, 1964, fire broke out in the building only minutes after the museum's closing time. The dry timber fueled flames that quickly engulfed the building. It was a total loss. Forest-products exhibits, including a display of the first Douglas fir plywood ever manufactured, were among the one-of-a-kind items lost to the fire.[70] Perhaps more significant, the fire meant the end of an era to longtime Portlanders who remembered visiting the building over the decades, including when it was part of the Lewis and Clark Centennial Exposition. The building had long served as a physical reminder of the city's past, but soon, all traces of it were gone forever. Like one of those "Where were you when…?" moments, those who were young Portlanders in 1964 can still recall the night the Forestry Building burned.

SOUTH AUDITORIUM URBAN RENEWAL AREA
AND INTERSTATE 405

Beginning in the late 1950s, Portland's first Urban Renewal project and the nearly concurrent construction of Interstate 405 transformed two significant and intersecting sections of downtown. During the course of more than a decade of redevelopment, the once bustling mix of older residential neighborhoods and commercial buildings was removed and replaced with apartment towers, office buildings, a series of small parks and a major urban freeway. The South Auditorium Urban Renewal Area spanned the area between about Southwest Columbia and Southwest Arthur Streets, between the river and Southwest Fourth Avenue. Meanwhile, Interstate 405 began near the southern edge of the Urban Renewal district, running west and then northward in a two-hundred-foot-wide swath.

In the early days of the city, small houses were scattered throughout the area known as South Portland. Things began to change in 1872 with construction of the city's first horse-drawn streetcar line, along First Avenue. This led to an influx of new buildings and houses; First Avenue became the heart of the neighborhood. While wealthier residents of the city moved westward into northwest Portland, and later up into the hills above downtown, South Portland stayed primarily a neighborhood for working-class and immigrant families. Jewish residents centered on First Avenue for their homes and businesses, while Italian immigrants, most of whom arrived after 1900, were scattered throughout the neighborhood.[71]

The neighborhood thrived in the first two decades of the twentieth century. The commercial district included all of the services one might expect in a dense urban neighborhood, including grocers, clothing stores and entertainment options like restaurants and motion picture theaters. However, as the resident families aged, adult children often moved away from the old neighborhood, seeking opportunities and home ownership in other parts of town. By the 1930s, South Portland was rapidly evolving into a neighborhood of older, longtime residents and single working-class adults renting rooms or living in shacks in and along Marquam Gulch, which crossed through the neighborhood.

By the end of the 1930s, the City of Portland was considering redevelopment opportunities in South Portland just as it was with Front Avenue, hoping to rid the city of so-called blight. However, whereas funding for Front Avenue and the development of Harbor Drive came in the early 1940s, South Portland remained mostly untouched for many years. Even

Allan deLay, aerial view of South Auditorium Urban Renewal Area prior to redevelopment, circa 1955. *Thomas Robinson Collection.*

after World War II, the area continued much as it had during the Great Depression, the primary difference being that many of the older buildings now suffered from lack of maintenance, and there was little financial support to repair or renovate them.

The Federal Housing Act of 1949, and its expansion in 1954, opened the door for wholesale clearance of neighborhoods in the United States under the banner of Urban Renewal. In 1955, Portland mayor Fred L. Peterson engaged a committee to examine the city and make recommendations as to which areas might be a good fit for an Urban Renewal project.[72] The committee identified a large portion of South Portland as ideal. In 1958, voters approved the nearly eighty-four-acre South Auditorium Urban Renewal Area, forcing 2,300 Portland residents to relocate as the city's new Portland Development Commission began acquiring property and demolishing almost all structures in it path. Twenty-six additional acres became part of the Urban Renewal Area in 1966. By 1962, the entire

neighborhood was gone and, along with it, the deep sense of community felt by longtime residents. The Portland Development Commission then began selling the land for new development.

The State of Oregon was one of the first to purchase part of the Urban Renewal land. By 1962, it was in the midst of planning a new freeway designed to circumnavigate the west side of downtown Portland. Originally billed as the Foothills Freeway or the Stadium Freeway, because of its location near Portland's Civic Stadium (now Providence Park), the new freeway was included as part of the Federal Interstate Highway program for the Portland area as Interstate 405. Plans for a through route to divert traffic from downtown streets was an idea dating to at least the early 1920s, as the primacy of the automobile became clear. The concept for such a roadway was expanded in the 1930s and again in the 1940s, but few actions were taken due to lack of funding. Finally, in 1955, as a new federal plan for interstate highways moved toward final approval, the Oregon State Highway Division drafted a report proposing fourteen new freeways for the Portland

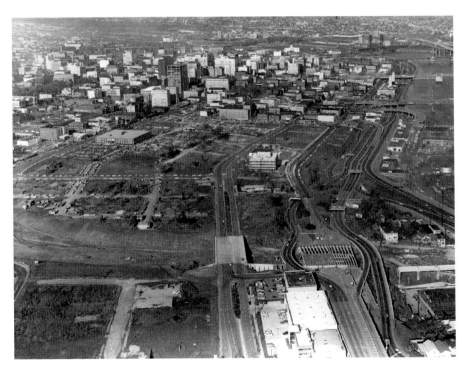

Aerial view of South Auditorium Urban Renewal Area and I-405 freeway construction after clearance, 1964. *City of Portland (OR) Archives, A2005-001.274.*

area. Included in this proposal was the Stadium Freeway. In 1956, President Dwight D. Eisenhower signed the Federal Aid Highway Act, and Oregon's freeway builders were ready to begin implementing their plans.

The exact location of the freeway became a hot topic in Portland in 1959. Work was already underway on Interstate 5, to the south of the city, and construction was soon to begin on the portion of I-5 on the east side of the Willamette River. Connecting the two segments would be the new Marquam Bridge, its western end rising high above the industrial areas of the South Portland waterfront. The southern end of I-405 would connect to the Marquam Bridge and I-5 in this same area. In the summer of 1960, the route for I-405 was selected. The new freeway would travel from the west end of the Marquam Bridge, through part of the urban renewal area westward. Beginning at about Southwest Fourth Avenue, I-405 would gradually turn to the north, running in a landscaped gulch. After traveling northward between Southwest Thirteenth and Fourteenth Avenues, the freeway would then veer slightly to the west between Northwest Fifteenth and Sixteenth Avenues, gradually rising above the streets below to its eventual connection with the new Fremont Bridge.

The segment of the freeway through the Urban Renewal district was noncontroversial, because the area had already been cleared of all structures by the time I-405 construction had begun. However, the route of the freeway affected hundreds of properties to the west and north of its starting point. Included in this route was St. Helens Hall, the former Portland Academy building that had stood on Southwest Thirteenth since the mid-1890s. Nearby, at Southwest Park and Clifton Street, a new synagogue that cost $600,000 to build was straight in the freeway's path. The Shaarie Torah congregation had just relocated after having lost their previous synagogue in the South Auditorium Urban Renewal Area. All told, more than three hundred residences and apartment units were in the path of I-405, as were about two hundred commercial buildings, in addition to several houses of worship. Construction on I-405 continued throughout the remainder of the 1960s, as sections of the road gradually opened. Finally, in 1973, the Fremont Bridge opened, connecting I-405 with I-5 in north Portland and thereby completing the freeway project.

The South Auditorium Urban Renewal Area and the construction of Interstate 405 displaced several thousand residents and businesses, forever altering the city's appearance and leaving little trace of the communities that once thrived throughout the affected area. In the Urban Renewal Area, new super-sized blocks replaced the old two-hundred-foot blocks that otherwise

define most of the city. New apartment buildings and architecturally interesting parks and fountains began to appear on these blocks starting in 1965, but it was now a completely different place. Gone were the secondhand stores, delicatessens and ethnic diversity for which the neighborhood had been famous. I-405 had a similar impact. In place of hundreds of early Portland homes, there is now only a handful of freeway overpasses and the roar of traffic below.

PORTLAND ACADEMY

The Interstate 405 freeway cut a swath through downtown Portland when it was constructed in the 1960s. In its path were numerous houses and historic buildings. Among them was the former Portland Academy. Built in 1895–96, the school stood along Southwest Thirteenth Avenue south of Montgomery Street in an area that today puts you right in the middle of Interstate 405.

The Portland Academy and Female Seminary, a Methodist-run institution, operated from the early 1850s until 1878. In 1889, a new Portland Academy was founded. Its leadership, however, was Presbyterian-leaning rather than Methodist. At the time, public high schools were only just beginning to catch on, and it seemed appropriate for the growing city to have a college preparatory school for young men and women. Land for the new school was donated by Henry W. Corbett, the wealthy Portland pioneer and former U.S. senator. Money for constructing the school building came from the estate of William S. Ladd, another of Portland's early settlers to have achieved great wealth through business and real estate dealings. The architecture firm Whidden and Lewis designed the school—probably the first Flemish-style building in Portland. The uniquely gabled roof, oculus windows and contrasting red brick and light-colored stone became common in the early twentieth century on campus buildings such as those found at Portland's Reed College.

While the school produced hundreds of future college graduates, including radical political activist John Reed and noted Portland-area residential architect Jamieson Parker, its financial success proved to be another matter. Tuition never fully covered the expense of operating the facility, and by 1912, those losses began to mount. The success of free public high schools in the city led to falling enrollment at the academy. After several years of increasing budget deficits, the school closed in June 1916.[73]

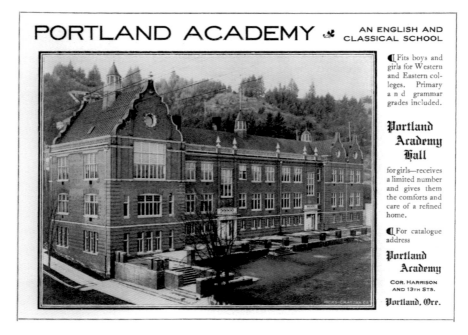

Portland Academy advertisement, *Portland Fire Department Souvenir Book*, 1905. *Architectural Heritage Center Library.*

In 1918, nearly four years after a fire caused them to relocate from its prominent hillside location, St. Helen's Hall, an Episcopal-run school for girls and young women, leased the former academy. In 1920, it purchased the building outright. St. Helens Hall continued to operate until 1964, at which time the State of Oregon purchased the building and the school moved to a new west-side location. In early 1965, the former Portland Academy was demolished for construction of the new freeway. Interstate 405 first opened to traffic in 1969.

LADD BLOCK

Another lavish 1880s design by Justus F. Krumbein, the Ladd Block stood on the northwest corner of Southwest First Avenue and Columbia Street. Krumbein adorned the three-story building with cast iron as well as a variety of unique stamped metal ornaments, including wolf heads that looked down

on the street from just below the building's mansard roof. A cast-iron roaring lion head just above the main entrance greeted visitors to the building. Above that, at the second floor, a hand-carved human head added a touch of Classical design to an otherwise Gothic building.

Built in 1881, the Ladd Block was but one in a long line of Portland-area buildings constructed on behalf of pioneer William S. Ladd. He had first come to Portland in 1851, not long after the city incorporated. By the end of the decade, he was one of the city's most successful merchants and had already served two terms as mayor of the young city before opening a bank with partner Charles E. Tilton. Ladd was the first to build in Portland using brick. The 1853 commercial building that carried his name stood on the west side of Southwest Front Avenue near Stark Street until the 1950s. In 1868, Ladd and Tilton built a new bank nearby at Southwest First Avenue and Stark Street.

Unlike his use of earlier buildings, Ladd did not intend to house one of his businesses in the Ladd Block. Rather, he sought to generate income from the retail storefronts, offices and rooms for rent on the upper floors. At the time of construction, the building was at the southern edge of the city's main business district. Perhaps Ladd believed the city would continue to expand in that direction, which it did, albeit as a working-class and immigrant neighborhood rather than an extension of the central business district.

Like much of the downtown area near the waterfront, the neighborhood in which the Ladd Block stood saw dramatic changes in the twentieth century. The main business district never quite extended to Southwest First and Columbia, and while a new auditorium opened only two blocks away in 1917, little new development occurred in the area after 1900. The result was that by the 1930s, many of the buildings were both underutilized and in need of repair. The Ladd Block, along with several neighboring buildings, survived the Great Depression and the Second World War era, but in the late 1950s, the implementation of the city's first official Urban Renewal Area all but erased the entire neighborhood just to the south of where the Ladd Block stood.

In 1965, owners of the Ladd Block, the Boyd Coffee Company, decided to demolish the building and its neighbor to the north, citing the prohibitive cost of rehabilitation. Just a few weeks earlier, the Portland Development Commission, the agency that implemented the city's Urban Renewal projects, had suggested the building could be a good example of historic rehabilitation as part of its ongoing downtown urban revitalization

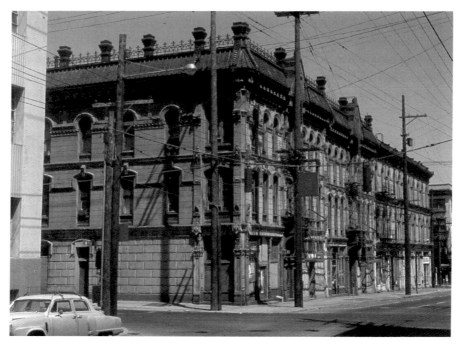

George McMath, Ladd Block,1964. *Architectural Heritage Center Library.*

program. The demolition of the building took place in early March, leading to finger-pointing in all directions. The building owners suggested that the city council had ordered them to demolish the building, a charge the council publicly denied.[74]

The demolition of the Ladd Block became a tipping point for historic preservation advocates in the city already contemplating measures to protect historic buildings in Portland. In the months that followed, architect George A. McMath and other activists called on the Portland City Council to delay demolitions of historically significant buildings for up to 180 days. Within three years, these efforts led to the creation of the Portland Historical Landmarks Commission and the first historic preservation ordinance adopted by the City of Portland.

ABINGTON BUILDING

Simeon and Amanda Reed are the namesakes of Portland's Reed College, established by Amanda Reed in the years after Simeon's death in 1895. What is less known about Simeon Reed is that, during the course of the more than forty years in which he lived in Portland, he was responsible for the construction of several significant buildings.

The Abington Building, on the east side of Third Avenue between Washington and Stark Streets, was the most important of Reed's downtown Portland buildings. Constructed in 1886–87, the building opened to the public in early 1888. In referring to the newly opened Abington, the *Oregonian* newspaper said the building marked the start of "a new era in the architecture of the city."[75] At four full stories and with a prominent central tower, the Abington (named after Reed's hometown in Massachusetts) was among the tallest and largest buildings in the city. With a cost of more than $150,000, it was also one of the most expensive buildings ever constructed in Portland. Included in the cost was one of the city's first passenger elevators. Built by the Otis Company of New York, the elevator car was made of solid mahogany and lined with beveled plate-glass mirrors.[76]

On its exterior, the building featured architectural elements like a mansard roof and Italian Renaissance arched windows. Much of the ornamentation was cast-iron, produced locally at John Honeyman's City Foundry. The building looked like an Italian palazzo, with each floor displaying unique decorative elements. A fire in 1908 caused extensive damage to the building, leading to the removal of the tower and mansard roof, but a full fifth floor was added.

Many local businesses relocated to the Abington when it first opened, including the architecture firm Williams and Smith, the successors to Warren H. Williams. Warren Williams had been Portland's most prominent architect for more than a decade when he died suddenly at the age of forty-four in January 1888. At the time of his death, Williams's younger brother Franklin and son David L. had already joined the firm, along with Arthur L. Smith as partner. Because of the firm's immediate relocation to the Abington when it first opened in 1888, it is possible that the company actually designed the building. Other businesses that would call the Abington Building home over the years included Cooke's Music School, Oregon Home Designers and what was in the 1920s–1930s Portland's largest realty firm, owned by Frank L. McGuire.

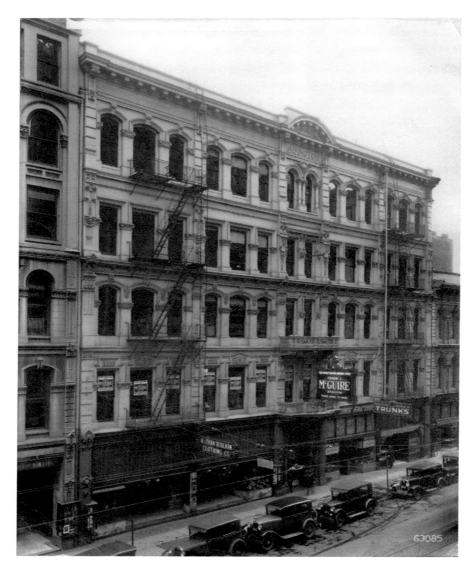

Abington Building, circa 1930. *Doug Magedanz Collection.*

Many of the new buildings constructed in the mid-1880s were west of Front and First Avenues. At the time, real estate developers viewed Third Avenue as an up-and-coming center of commerce. The Abington, therefore, was seemingly in a prime location, but by the turn of the twentieth century, the downtown business district had continued to move even farther west. This

emerging business and entertainment center bypassed Third Avenue with a new era of buildings centered along Fifth, Sixth and Seventh (Broadway). A valiant effort by businesses on Third Avenue to maintain their popularity by installing lighted archways and rebranding the street as the Great Light Way was waylaid by the onset of the First World War. After the war, the streets nearest the river struggled to maintain their commercial appeal. This included buildings along Third Avenue like the Abington Building.

In 1927, H.B. Davis, the owner of a local iron and steel company, purchased the Abington Building and renamed it the Davis Building. In 1965, R.B. Pamplin Incorporated acquired the erstwhile Abington Building and its neighbor to the north, the McKay Block. In 1967, Pamplin demolished the two buildings in order to make way for a surface parking lot.

5

1969–2017

Loss in the Age of Preservation

The ebb and flow of architectural loss in Portland has continued throughout recent decades. Unsurprisingly, demolitions rise along with the economy and with increasing pressure to add housing or modern amenities, or to revitalize neighborhoods.

Portland's historic preservation movement formally took hold in 1968 with the enactment of the city's first preservation ordinance. At different times, the City has been as much an opponent of old buildings as it has been proactive in trying to save them. Coupled with the challenges of identifying new uses for old buildings, the preservation movement has struggled to keep pace.

Institutions have outgrown their facilities and moved elsewhere, leaving behind entire complexes. Work to revitalize downtown sometimes caused the demise of once prosperous commercial buildings. Through the 1970s, the creation of new surface parking lots in place of old buildings continued, and many are still there. In other instances, preservationists secured small tokens of remembrance for lost buildings. But as the memories of those old buildings have faded, so have the memorials.

Sometimes there really is no viable solution to demolition. Too often, however, buildings fall into disrepair out of neglect and then, later, their condition becomes an excuse for why they should be demolished. There have been some "good" losses, too, and those should be recognized. The 1969 demolition of the former Public Market building served as the first step toward removing a highway and creating a waterfront park. As interesting as the old market building might have been, few people would argue that its continued presence would have benefited the city as much as the park.

PUBLIC MARKET

One of the most controversial buildings ever constructed in Portland, the enormous Public Market building once stood along the Portland waterfront between the Hawthorne and Morrison Bridges.

As early as the 1910s, Portland had an unofficial and very successful public market along Southwest Yamhill Street between First and Fifth Avenues. But as the 1920s unfolded and the city sought to clean up the waterfront and make the area less prone to flooding, the idea that a new market could be located along Front Avenue began to draw interest. In 1927, a group of wealthy Portland investors founded the Portland Public Market Company and began negotiating with the city to gain its support for a waterfront building site as well as assurances that the city would acquire the market once it was up and running. After a series of questionable deals, the Portland City Council offered its support for the project in 1931.

Operators of market stalls along Southwest Yamhill were outraged at the decision to build the market so far away from the central business district. Other opponents of the project expressed concern about the location because it required crossing the very busy Front Avenue in order to get to the market building. Despite the opposition, none of the proponents of the waterfront market site wavered in their opinion of the chosen location. In the spring of 1933, the federally run Reconstruction Finance Corporation (RFC) offered to loan more than half of the $1.4 million construction cost, supporting a project that would create jobs for hundreds of workers during the Great Depression. Work began in earnest on the concrete building, and the market opened just before Christmas in 1933.

In a project that was clearly driven by insiders, the design for the market came out of the architecture offices of Lawrence, Holford, Allyn and Bean. Ellis Lawrence, a successful architect of Portland-area houses and commercial and institutional buildings, was a member of the Portland Planning Commission, a body that supported the selection of the building site. Sydney B. Hayslip, an architect who worked for Lawrence, was chosen to oversee the project's completion as supervising engineer while supposedly doing so on behalf of the RFC. Ormond Bean, a partner in the Lawrence firm, ran for city council in the fall of 1932 and won.

The market building was a massive concrete structure, more than six hundred feet in length and three full stories tall. A portion of the building extended to a fourth floor, with twin towers projecting high into the sky. The mass and horizontal nature of the building emphasized its Streamline

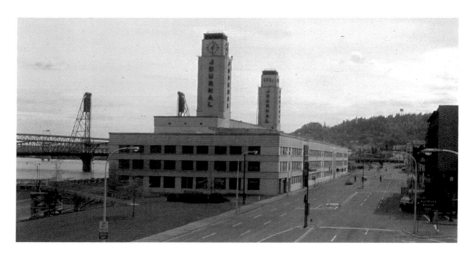

Maxine Crookham, Public Market, circa 1968. *Architectural Heritage Center Library.*

Moderne style. It was a perfect example of a building for the motor age. Included were parking spaces for 650 vehicles, nearly 300 farm stalls and 100 retail shops. Among the many businesses were coffee, beer and tobacco vendors, as well as a drugstore, beauty salon, several florists and a Chinese grocery. It was truly a full-service mall-like facility.

Such an expensive project was always going to be difficult to maintain financially. The original investors in the project assumed the City would take over the market once it opened, but a new administration in City Hall balked at that plan. Almost from the outset, it seemed that the likelihood of the market's long-term success was doubtful. In January 1934, only weeks after the market opened, new mayor Joseph Carson publicly expressed opposition to the market project, as did two other city commissioners, including, oddly enough, Ormond Bean. Years of legal battles over ownership of the market ensued.

After a decade of legal wrangling, the market closed on January 1, 1943. Neither the city nor the Portland Public Market Company wanted to run the market or be responsible for such a big building. For the duration of World War II, the U.S. Navy leased the building. In 1946, the *Oregon Journal* newspaper purchased the former market. By this time, changes to Front Avenue and the construction of the Harbor Drive expressway made the possibility of using the building for retail purposes even less likely. In 1968, the city finally purchased the building, something it was supposed to have done more than three decades earlier, but by this time, it was no longer interested

in running a public market. In July 1969, the building was demolished in what became the first phase of removing Harbor Drive, eventually leading to the development of Tom McCall Waterfront Park.

Portland historian E. Kimbark MacColl once described the market story as "the Public Market Fiasco."[77] Indeed, the rise and fall of the Portland Public Market left quite a bit of wreckage in its wake. Its development led to the loss of an already vibrant market scene in downtown. It took decades before the successful Portland Farmers Market finally offset the loss of the original public market. Meanwhile, the eventual demolition of the waterfront Public Market building was an important first step for a city wanting to reclaim its downtown waterfront as a public space for residents and visitors to enjoy.

ST. MARY'S ACADEMY

Founded in 1859 by the Sisters of the Holy Names of Jesus and Mary, St. Mary's Academy continues to operate from nearly the same location as it did more than 150 years ago along Southwest Fifth Avenue between Market and Mill Streets. Originally, the school operated out of a house on the west side of Fifth Avenue, but by the 1880s, school officials sought to build an all-new facility on the east side of the street.

In 1889, school officials hired architect Otto Kleeman to design their new building. Kleeman was still in the first half of a lengthy career in Portland that included his design of the still extant St. Patrick's Cathedral in northwest Portland, as well as numerous houses and commercial buildings scattered all over the city. His design for the school was modest, not nearly as flamboyant as other schools constructed around the same time, such as St. Helens Hall or the Portland High School built just a few years earlier. Incorporated into the building was a chapel dating to the earliest days of the school, creating continuity between the past and present. Topping the rectangular four-story building was a prominent octagonal tower that rose to a height of 140 feet above the street. The slightly elevated location of the school, combined with the tower height, provided nearly unobstructed views of the city in all directions.

The school prospered and within a few years began offering college-level degrees, making the school unique as compared to some of its contemporaries. The college would later branch off from St. Mary's Academy; it operates today near Lake Oswego as Marylhurst University but is slated to close

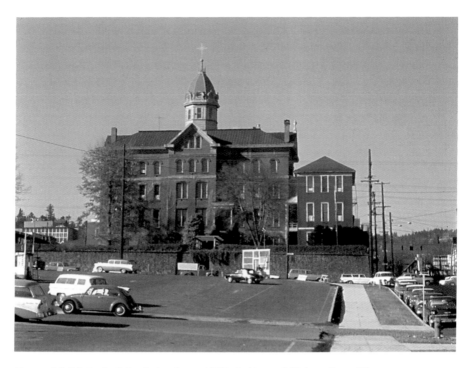

George McMath, St. Mary's Academy, 1964. *Architectural Heritage Center Library.*

by the end of 2018. Meanwhile, private schools in Oregon like St. Mary's almost did not survive the 1920s. A ballot measure pushed by the Masons of Oregon—and supported by the Ku Klux Klan and newly elected governor Walter M. Pierce—would have required nearly all children between the ages of eight and sixteen to attend a public school. Although Oregon voters approved the measure, it immediately ended up in court, with the Sisters of the Holy Names leading the fight. The U.S. Supreme Court ruled the law unconstitutional in 1925, thereby preserving private education in Oregon and ultimately across the nation.

In 1940, construction began on a new school building, back on the west side of Fifth Avenue at the original site. Over the next twenty-five years, that building would be expanded multiple times, while use of the old structure began to wane. In the 1950s, the old building found itself on the edge of Portland's first Urban Renewal project. The South Auditorium Urban Renewal Area erased a large swath of commercial and residential buildings, forcing longtime residents into other parts of the city. As the area was

redeveloped with apartment towers, parks and fountains, the old St. Mary's school building remained. Then, in 1965, the building closed for good after the most recent addition to its newer facility was completed.

In April 1970, the old St. Mary's Academy building was sold. Preservationist Eric Ladd acquired the old chapel, moving it off the school property just prior to the main building's demolition that fall. Efforts to find a new home for the chapel were not successful, and it was later demolished. The site of old St. Mary's has been a parking lot since 1971. Remnants of the original retaining wall that surrounded the old school remain.

SELLING-HIRSCH BUILDING

Ben Selling and Solomon Hirsch were already among the leading merchants in Portland by the time they collaborated in 1895 on a new building along Southwest Washington Street between Ninth and Tenth Avenues. Selling had run a successful clothing store for many years, and Hirsch had been a partner in a local dry goods business since the late 1860s. Both were active in local politics, having served in the state legislature. In 1889, President Benjamin Harrison appointed Hirsch as the U.S. envoy to Turkey. Unlike some of their contemporaries, they managed to survive the economic collapse that occurred in 1890s Portland. They purchased the property for their new commercial building from Julius Loewenberg, then in the midst of losing much of his fortune.

Construction on the Selling-Hirsch Building began in 1895 and was completed the following year. The building was not tall for its time, only three stories in height, but it filled half a city block. Brick and sandstone were popular building materials in 1890s Portland, but the architectural details on the Selling-Hirsch Building were unique, including the light-colored brick used at the corners and as window lintels, in contrast to the rest of the redbrick façade. The main entrance on Washington Street was the most ornamental part of the building. High above the entrance, three pairs of fluted pilasters adorned with garlands framed a pair of equally decorative oculus windows. The letters "S" and "H" adorned a third-floor iron balcony railing, the only clue as to the two men behind the building's construction.

Throughout the seventy-plus years that the building stood, it housed a variety of popular businesses and notable organizations. The uppermost floor contained a large meeting hall, first occupied by the Woodmen of the

Hazelwood Cream Store in the Selling-Hirsch Building, circa 1910. *Architectural Heritage Center Library.*

World fraternal lodge and later used by the Council of Jewish Women prior to construction of their Neighborhood House in Southwest Portland's Lair Hill neighborhood. In 1912, the Portland Equal Suffrage League, organized by Josephine Hirsch, widow of Solomon Hirsch, used the building for its meetings. That fall, Oregon voters finally gave women the right to vote after several earlier attempts had failed. In the 1930s, the Portland Creative Theater Company used the hall for dramatic readings, plays and music recitals. The Red Cross taught evening nursing classes in the hall during the Second World War.

Numerous small businesses, music teachers and artists operated out of the Selling-Hirsch Building, but the main floor contained a few longtime tenants. Joseph Shemanski's Eastern Outfitting Company operated out of the corner at Tenth and Washington for about twenty-five years, until he moved into a new building kitty-corner on Tenth Avenue. Shemanski later donated the fountain bearing his name that still stands in the South Park Blocks between Salmon and Main Streets. From the early 1900s until around 1930, the Hazelwood Creamery operated an ice-cream parlor from a street-level storefront in the building. The Hazelwood space included one of the most imaginative entrances ever to adorn a Portland building—

looking much like a Swiss farmhouse. The Bohemian Restaurant also occupied a ground-floor space in the building for several decades, finally closing in 1968. The Bohemian was famous with tourists and locals alike for its Crab Louis.

In 1967, the Selling-Hirsch Building was sold along with the other buildings on the block. Only months later, the businesses were shuttered; in 1971, the entire block of buildings was demolished. The site has been a surface parking lot since that time. As of 2018, the block is perhaps most known for the number of food carts that ring the parking area, but a new high-rise building may soon be constructed on the site.

ST. VINCENT'S HOSPITAL

The Sisters of Providence have provided medical care in the Portland area since before Oregon statehood in 1859. In those early years, however, Portland did not have its own hospital. Patients were forced to travel to Vancouver or Oregon City if they needed care beyond that of physicians in the young city. In 1874, the sisters began seeking funds for a new permanent hospital in northwest Portland. Thanks to a donation of land by the local chapter of the St. Vincent de Paul Society, a block in northwest Portland bounded by Eleventh Avenue, Twelfth Avenue, Marshall Street and Northrup Street became the site for their new hospital. Designed by Mother Joseph, leader of the Sisters of Providence in Portland, the first St. Vincent's Hospital opened in 1875.

By 1883, the Sisters of Providence recognized that they already needed a new and larger facility, preferably away from the hustle and bustle of the city.[78] After much fundraising, five years later, they were able to purchase a piece of land along present-day Northwest Westover Road, above Twenty-Fourth Avenue. Finally, in 1892, construction began; three years later, the first patients arrived at the new hospital.

Architect Justus F. Krumbein designed the new St. Vincent's Hospital. At five full stories in height, plus a basement, the hillside building stood just above a residential neighborhood. Like in some of his other projects from the period, Krumbein blended stone and brick, but not completely in the popular Romanesque Revival style. The building reflected Krumbein's eclecticism, such as a domed tower at one end of the building that projected above a multistory bay window and a prominent college-like stepped gable

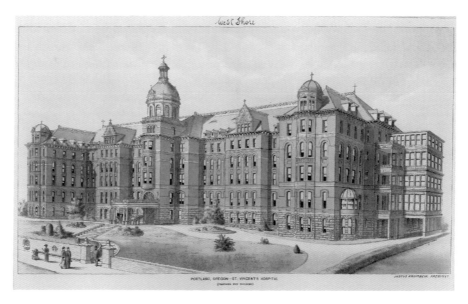

St. Vincent's Hospital lithograph, *West Shore Magazine*, November 1, 1890. *Architectural Heritage Center Library.*

with an oculus window, perhaps hinting at the fact that the hospital also served an educational function.

The hospital's neighborhood presence continued to grow well into the twentieth century, in particular because of an ever-expanding nursing school. In 1910, a new residential hall for nursing students opened adjacent to the hospital. The nursing school itself expanded with the 1930 opening of a new seven-story building that was taller than the main hospital.[79]

By the 1960s, the hospital had again outgrown its location; in 1966, it announced plans for a new facility. Indicative of the growing suburban population, the site chosen for the new hospital was on the other side of the West Hills from the 1890s location along Westover. The new St. Vincent's Hospital opened in 1971, and the old site was soon put up for sale. In 1973, a development company purchased the old hospital site, announcing plans for a large condominium project, one of the first such projects in Portland to draw the ire of neighbors. Over the next two years, the building was emptied of all its contents. Stained-glass windows were salvaged and sold, as were windows and doors. By the end of 1974, the old hospital stood as a hulking shell, ravaged by vandalism. Meanwhile, the scope of the proposed condominium project was reduced, thereby finally gaining neighbors' acceptance. For such a large complex, the demolition of St. Vincent's Hospital was met with little

organized opposition. Neighbors were mostly opposed to the buildings that would replace it. Demolition of the remains of the old hospital began in late 1977 and proceeded into the following year. A variety of condominium buildings now occupy the site where the hospital once stood.

JEANNE D'ARC

There were not many large buildings west of Southwest Twelfth Avenue in 1890 Portland. That area was still mostly residential with remnants of small farms occupying what was then an uneven landscape. Things began to change in 1891, when Henry H. Northrup decided to build a new residential-style hotel on what is now Southwest Fourteenth Avenue near Jefferson Street. In addition to being an attorney, Northrup was also serving in the state legislature at the time. He never intended to operate the hotel himself, hiring Virginia Hill, a well-known Portland-area boardinghouse operator, to run his new venture.

Opening in the late fall of 1891, the four-story Hill-Ton (commonly referred to as "the Hill") served as an alternative to the more centrally located Portland Hotel that had opened the previous year. Architect Isaac Hodgson Jr. designed the building. Hodgson, a newcomer to the city, was in the midst of a brief and controversial career in Portland. Construction of the new chamber of commerce building he designed was still underway as the Hill-Ton opened. Like the Portland Hotel, the brick and stone Hill-Ton was another departure from the wood-framed hotels that Portland had known since the 1850s. Its round arched windows on the upper floors and rustic stone at the basement-level exterior reflected the Romanesque Revival style that was quickly catching on in the city. Two floors were later added to the building, making it six stories tall. A mansard roofline gave it a French Chateau appearance.

Management and ownership of the hotel changed several times prior to the start of the First World War, as did the building's name. For several years, it was called the Hobart-Curtis, but that changed when Virginia Hill returned to managing the hotel in 1909. By this time, Northrup, now a Multnomah County judge, was no longer involved in the operation, having sold the building and property to Adolph B. Steinbach, a prominent Portland clothing-store owner and real estate investor. For the next decade, it operated once again as the Hill and then the Virginia Hill. By the end of the war, business had begun to falter at the hotel. In 1919, the building and property

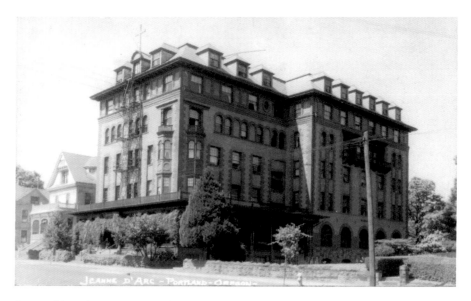

Jeanne d'Arc, circa 1940. *Norm Gholston Collection.*

were sold to the Catholic Sisters of Mercy, who renamed the building the Jeanne d'Arc. Over the next forty-five years, the Jeanne d'Arc served as a home for young working women.

In 1964, local developers purchased the Jeanne d'Arc and renamed it the Princess while maintaining it as a women's-only apartment building. Four years later, it sold again. This time, the new owners renamed it the Marabba West, supposedly after an "East Indian god."[80] Around 1970, KGW Television purchased the building and property, allowing it to continue operating for several more years, during which time the building managers opened a coffee shop while also hosting dance and theater performances as well as political meetings.

Wanting to expand its adjacent television studio facilities, KGW decided to demolish the aging building, closing the Marabba West and boarding it up in the summer of 1977. Hoping to save the building, historic preservationists tried to convince both Portland State University and the City of Portland to purchase it from KGW. Neither thought that the building was worth the amount of money it would cost to renovate in order to meet current building codes. Demolition of the building began in September 1977. Much of the property on which the Jeanne d'Arc once stood has been used as a parking lot since that time.

CONGRESS HOTEL

Wood, brick and cast iron were the dominant materials found in Portland commercial buildings erected prior to the turn of the twentieth century. By the early 1900s, this began to change as new building materials became more widely available. Chief among these were reinforced concrete and terra-cotta.

Located at Southwest Sixth Avenue and Main Street, the Congress Hotel was built in 1911–12 and designed by architect David L. Williams, son of noted Portland architect Warren H. Williams. David Williams had been practicing architecture since the late 1880s, but as times, tastes and materials changed, he successfully adapted his career to meet the demands of his clients. Just three years earlier, Williams had designed one of the first reinforced-concrete office buildings in Portland, the Moy Building, which still stands at Southwest Second and Yamhill Street.

Hedwig Smith, son Alfred and son-in-law Charles J. Schnabel were the original co-owners of the Congress Hotel. The Smiths were able to finance the project thanks to the fortune amassed by Hedwig's husband, Charles, who had co-owned Portland's Smith Brothers and Watson Iron Works. The eight-story hotel opened in early 1912 in the midst of a downtown building boom, advertising its fireproof construction with state-of-the-art facilities, including private bathrooms and telephones.[81] In 1921, co-owner Charles Schnabel, a longtime practicing attorney, was shot and killed by a former client, leaving the hotel in the hands of the Smiths.

The hotel was immensely successful from the outset, so much so that in 1924, the Smiths decided to expand. For the addition of an eight-story annex and the complete remodel of the original structure, the Smiths hired architect Herman Brookman. Brookman had arrived in Portland less than two years earlier to design a house for M. Lloyd Frank; the landmark building is now part of the Lewis and Clark College campus. Brookman's design of the revamped Congress Hotel and its annex turned a relatively simple hotel into a grand two-hundred-room complex. The exterior boasted elaborate terra-cotta ornamentation, then at its peak in popularity. Between the turn of the twentieth century and the onset of the Great Depression, the vast majority of new downtown Portland commercial buildings were adorned with terra-cotta—a lightweight material that could be glazed, left with a natural finish or made to look like hand-carved stonework. On the Congress Hotel, the terra-cotta, including ram's head keystones and fruit and floral motifs, gave the

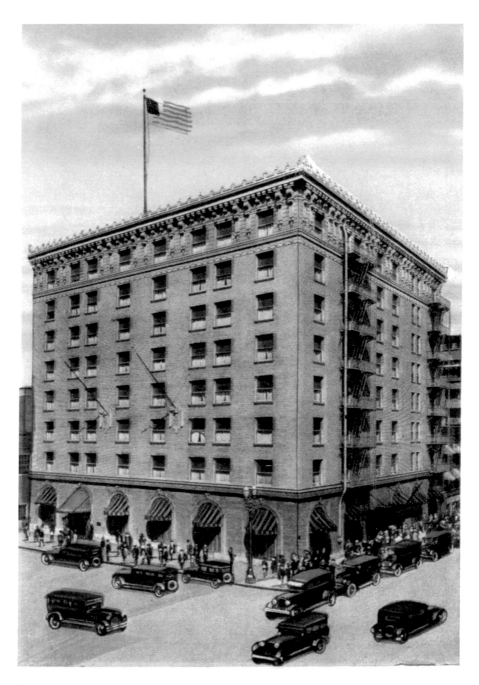

Congress Hotel, circa 1925. *Architectural Heritage Center Library.*

impression of fine stonework, belying the fact that it had been hand-pressed into molds and baked.

Located in the heart of what was at the time a growing central business and government district, the Congress was popular with visiting dignitaries, celebrities, sports teams and local and visiting politicians. Candidates Hubert H. Humphrey, Eugene McCarthy and Robert F. Kennedy all held events or stayed at the hotel during the 1968 presidential campaign. However, by the early 1970s, business at the hotel had begun to decrease, exacerbated by construction of the downtown Portland Transit Mall on Fifth and Sixth Avenues. Even though the loss of the Congress created a shortage of hotel rooms in the city, the hotel closed permanently in the summer of 1977. In early 1978, it was demolished and replaced by a twenty-three-story office tower, the Orbanco Building (now called the Congress Center), which opened in 1980.

At the time of demolition, historic preservationists lobbied to save some of the beloved ornamental terra-cotta from the old hotel. The salvaged pieces, including several ram's heads, were used to decorate a gazebo entrance to a subterranean restaurant and bar located at the southwest corner of the Orbanco Building property. As of 2018, the gazebo is still standing, but its future is unclear.

AHAVAI SHOLOM SYNAGOGUE

Ahavai Sholom was one of several synagogues that once stood in the southern portion of downtown Portland. The congregation was founded in 1869 by a group of conservative Prussian Jews. By the beginning of the twentieth century, the congregation had outgrown their small building on Southwest Sixth Avenue between Pine and Oak Streets, a building they had occupied for several decades.[82]

In 1904, architect Edgar Lazarus was hired to design a new synagogue for the congregation on the northeast corner of Southwest Park Avenue and Clay Street. Lazarus was born in South Carolina and studied architecture at the Maryland Institute of Art and Design before moving to Portland in 1891.[83] Lazarus is best known for his design of the Vista House at Crown Point on the Historic Columbia River Highway, but he also designed several houses in Portland and served as supervising architect for construction of the U.S. Custom House (built in 1902), still standing along Portland's North

George McMath, Ahavai Sholom Synagogue, 1973. *Architectural Heritage Center Library.*

Park Blocks. Costing an estimated $25,000 to build, the new Ahavai Sholom Synagogue was dedicated on September 4, 1904.

On November 5, 1923, a fire seriously damaged the synagogue only weeks before another fire destroyed Beth Israel Synagogue a few blocks away. In March 1925, police arrested a Portland firefighter named Chester C. Buchtel, who soon confessed to starting eighty-one fires over a two-year period, including the Beth Israel and Ahavai Sholom blazes. The Multnomah County Circuit Court eventually ruled that Buchtel was insane and committed him to the Oregon State Hospital in Salem.[84]

After repairing the building, the Ahavai Sholom congregation remained at their Park Avenue location until 1952, at which time they moved to another new building, located at Southwest Thirteenth and Market Street. In 1961, Ahavai Sholom merged with another local congregation, Neveh Zedek, and became Congregation Neveh Shalom. Around this same time, the congregation learned that their relatively new synagogue was in the path of the new I-405 freeway. Faced with the destruction of their synagogue, the congregation decided to move out of downtown. In 1964, they moved to a new location in the Hillsdale neighborhood that remains their home to this day.[85]

The 1904 Ahavai Sholom building served a variety of uses after the congregation left in 1952. Portland State College (now Portland State

University) used the building as a gymnasium before selling it to the First Evangelical Church in 1969. The church used the building for Sunday school and other youth activities before relocating its entire congregation to the west-side suburbs. In 1978, the Portland Historical Landmarks Commission nominated the building for landmark status, but before the Portland City Council could vote on the nomination, the old synagogue was demolished.[86] A decade later, a new apartment complex was built on the site.

LENOX HOTEL

By 1906, architect Emil Schacht was in the prime of his career. He was already established as a designer of fine houses around the Portland area and in 1905 became even more well known with the enormous three-hundred-foot-long Oriental Exhibits Building he designed for the Lewis and Clark Exposition. Less than a year after the exposition closed, Portland businessman Emil C. Jorgensen hired Schacht to design a new building for him on Portland's Southwest Third Avenue between Main and Madison Streets. Though it was originally intended to be an office building, not long after the project started, Jorgensen directed Schacht to turn the building into a hotel instead. Schacht adorned the new building with Classical Revival details, blending a primarily brick exterior with architectural ornament made of terra-cotta, marble, wrought iron and copper.[87] Seven-foot-tall wainscoting, also made of marble, and wood paneling adorned the walls in the hotel lobby and adjacent hallways.

Interestingly, nobody seems to know where the Lenox got its name. It is possible the name gave the hotel an air of prestige, as similarly named hotels had opened only a few years earlier in Boston and other eastern cities. The four-story hotel opened in the summer of 1907 and was an immediate success, with its view of Chapman Square Park across the street. While Jorgensen owned the building and property, the initial hotel manager was Freeman E. Daggett. Unfortunately, Daggett, an experienced hotel operator, died less than six months after the Lenox opened; the hotel then went through a series of management changes. Finally, in 1909, Jorgensen's two sons, Edwin D. and Victor H., began running the hotel.

In 1923, Emil Jorgensen died, leaving the Lenox to his sons, who continued to operate the hotel for another two decades. In 1936, the Jorgensen brothers gave up day-to-day management of the hotel while still maintaining

Lenox Hotel, circa 1910. *Library of Congress, Prints & Photographs Division, HABS ORE, 26-Port, 5--26.*

ownership of the building and property. That same year, the subsequent hotel operators redecorated and renamed it the New Lenox Hotel. By the 1950s, the hotel had begun to cater more to permanent residents rather than out-of-town visitors. A series of small fires in the 1950s and 1960s did little to help the reputation of the fading hotel; neither did the October 1968 shooting of a bartender at Frank's Parkview Inn, a tavern that occupied one of the building's storefronts. In 1974, new fire code regulations led to the closing of the hotel altogether.

After the hotel closed, new tenants attempted to convert the Lenox Hotel into low-income housing but failed to obtain adequate financing. In 1979, the Jorgensen family sold the building to the Portland Development Commission, which proceeded to demolish it the following year. The Multnomah County Justice Center has stood on the site since 1983.

CORBETT AND GOODNOUGH BUILDINGS

The Corbett and Goodnough Buildings, two of the more prominent downtown buildings of their time, once stood on the east side of Southwest Fifth Avenue between Morrison and Yamhill Streets. Constructed in 1891, the Goodnough Building was another of the city's Romanesque-styled buildings, while the Corbett Building, constructed in 1907, was one of Portland's first steel-framed structures.

In late 1890, Ira E. Goodnough hired architect William Stokes to design a new commercial building to become, in part, the new home of the Portland Business College, a school that taught men and women skills such as penmanship, typing and stenography. Stokes was the designer of Portland's first high school, one of several projects he completed in Portland during the 1880s and 1890s. Stokes's architectural designs were known for their lavish use of exterior decoration. His initial design for the Goodnough Building included a corner tower and decorative parapet. The finished building, however, was far more conservative. The tower was never constructed, and exterior ornament was kept to a minimum. Rustic stone arches over the building entrances and above upper-floor windows gave the building a sturdy yet modest Romanesque Revival appearance.

Work started on the six-story Goodnough Building in 1891, and the building opened in early spring 1892. With the college occupying the top floor, the rest of the building included offices, retail outlets, a music school and a music hall offering live performances. The college moved out in 1899, and in 1902, the Goodnough Building became the first home of the *Oregon Journal* newspaper. In 1912, the *Journal* moved into its new building, now known as the Jackson Tower, which still stands at Southwest Broadway and Yamhill Street.

Meanwhile, the Corbett estate, led by Elliot R. and Henry L. Corbett, owned the property to the north of the Goodnough Building on Fifth Avenue. In 1906, they hired the architecture firm of William Whidden and Ion Lewis to design a new ten-story office building for the property using the latest construction methods. Downtown Portland was just beginning to see an influx of new and taller commercial buildings constructed in the Italian Renaissance or Classical Revival style. The Corbett Building was part of this new trend. It, along with the Wells Fargo Building, five blocks away at Southwest Sixth Avenue and Stark Street, represented the arrival of the modern steel-framed skyscraper to Portland.

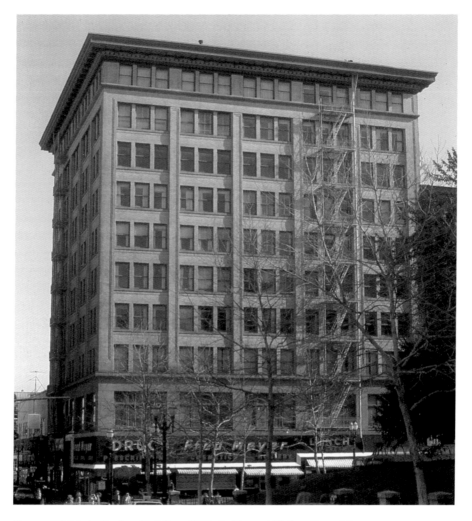

George McMath, Corbett Building, 1984. *Architectural Heritage Center Library.*

The Corbett Building officially opened in early 1908. Occupying the ground floor was the Security Savings and Trust Company, with the rest of the building mostly dedicated to professional offices, including numerous physicians and dentists. In 1914, Security Savings merged with Portland's First National Bank and announced plans for a new building several blocks away at Southwest Fifth and Stark Street. When the new bank opened in late 1916, the main floor of the Corbett Building was reconfigured into a men's clothing store and later became an Oregon City Woolen Mills store.

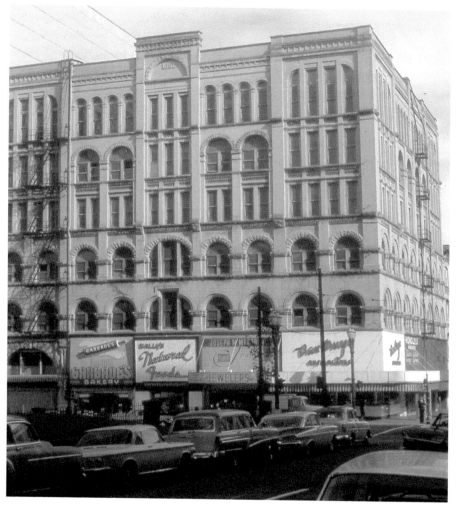

George McMath, Goodnough Building, 1962. *Architectural Heritage Center Library.*

The Corbett and Goodnough Buildings shared parallel paths throughout their existence. Both buildings saw their upper-floor office spaces become less desirable over the years, while their ground-floor storefronts were adapted to new and perhaps less prestigious tenants. In 1942, Fred Meyer opened one of his "one-stop shopping" stores on the main floor of the Corbett Building. But, as Meyer began expanding throughout the city, the Corbett Building location became more famous for what it did not offer rather than for what it did. Advertisements

for the chain regularly touted product availability at all stores "except Morrison."

By the early 1940s, the top floor of the Goodnough Building, once occupied by the Portland Business College, had been converted into a rooming house. In 1950, the building's new owner closed off the upper floors of the building altogether, going so far as to cover the sandstone arched main entrance. The popular chocolatier Van Duyn's moved into one of the storefront spaces, sharing the ground floor with a bakery, jeweler, lounge and a natural food store. The remodeled storefronts masked the building's architecture until a remodel in 1979 once again exposed the original storefronts.

By the end of the 1970s, the Corbett and Goodnough Buildings faced an uncertain future. The downtown transit mall, along Fifth and Sixth Avenues, was recently completed, and work was about to commence on the new Pioneer Courthouse Square. City officials continued to consider ways to encourage more people to visit downtown. In 1979, a proposal for a massive redevelopment on the city block that included the Goodnough and Corbett structures gained the city's support. Although the initial project failed to materialize, the Portland Development Commission began acquiring properties on the block. Historic preservationists hoped whatever redevelopment occurred would include the renovation of the two buildings, but as the project slowly moved forward, that began to seem unlikely. Finally, in 1983, the Portland Historical Landmarks Commission concurred that redevelopment of the entire block outweighed the significance of the two historic buildings.

Preparations to demolish the two buildings began in 1987, as they were emptied of tenants. In early 1988, the Goodnough Building was summarily demolished. The Corbett Building, however, received a much more dramatic sendoff. To date, the implosion of the building on May 1, 1988, marks the only time in Portland history that a building was taken down in such a manner. The Pioneer Place shopping mall opened on the block in 1990.

PORTLAND GAS AND COKE COMPANY BUILDING

With a design reminiscent of an old schoolhouse, including a distinctive clock tower, the Portland Gas and Coke, or GASCO, Building was famous as a roadside ruin. Located off Northwest St. Helens Road, just south of the St. Johns Bridge, the GASCO Building was made of concrete formed

to give the appearance of stone, giving the building a very Gothic and monolithic appearance.

The Portland Gas and Coke Company was the predecessor to NW Natural—the primary supplier of natural gas throughout the Portland area today. The company incorporated in 1910 when the New York–based American Power and Light Company acquired the Portland Gas Company. At the time, gas was still competing with electricity for the purposes of lighting. It soon became clear that gas could also become a principal fuel for cooking and heating. The gas produced by the Portland Gas and Coke Company was made through a process of extracting gas from oil.

In 1912, Portland Gas and Coke announced plans for a new gas production facility on the banks of the Willamette River in Northwest Portland.[88] Opened in 1913, the new plant included gas production facilities, storage tanks and a three-story office building. In addition to gas production, the company also made briquettes for burning in fireplaces and furnaces. This new heating source created competition for the slab wood producers that had been supplying wood to heat Portland houses since the 1870s. The briquettes were popular because of how long they

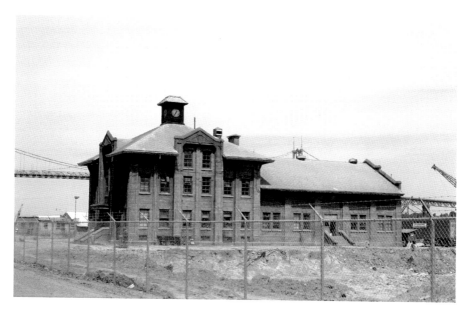

Marion Dean Ross, Portland Gas & Coke Company Building, 1980. *Courtesy of the University of Oregon Libraries.*

burned and because they generated little ash as compared to wood. The downside was that the process used to create them tainted the soils around the gas plant complex with dangerous chemicals. For more than forty years, the plant produced gas and briquettes, but in 1956, compressed "natural gas" arrived in Portland via pipeline. In 1958, the Portland Gas and Coke plant was shuttered. In 1966, most of the plant was demolished with the exception of the former office building.

For fifty years, the old GASCO office building stood abandoned. In 1988, NW Natural donated the clock to Oregon State University in Corvallis. Benton Hall on the university campus had a clock tower constructed in 1896, but, due to a lack of funding, the school had never installed a clock. The 1989 installation of the former GASCO clock marked the revitalization of the historic Benton Hall while signaling the future demise of the GASCO Building.

Over the ensuing decades, the building wasted away, but it also attracted interest from passersby as a near ruin. Just as the building surpassed the one-hundred-year mark, NW Natural announced plans to demolish it. Over the course of two years, groups and individuals alike tried to come up with creative solutions and the funds for preserving the now dangerously dilapidated building. One idea was to stabilize the structure but keep it otherwise as a ruin, much as one might see an old castle high above the Rhine River in Germany. Nevertheless, efforts to raise the funds necessary to save the structure failed. The GASCO Building was demolished in the fall of 2015.

HOLMAN FAMILY HOUSE

Built in 1892 by one of Portland's most civic-minded families of the era, the Holman Family House was located at Southwest Fifteenth Avenue and Taylor Street. For several decades, it was home to brothers Frederick and George and their sisters Frances and Kate Holman.

Frederick V. Holman is the best known of the siblings who lived together in the house. He was a Portland attorney and onetime president of the Oregon State Bar. He was also an avid rose gardener and one of the cofounders of the Portland Rose Society. In late 1901, he wrote a lengthy op-ed in the *Oregonian* newspaper calling on area residents to help beautify Portland for the upcoming 1905 Lewis and Clark Centennial Exposition by creating a

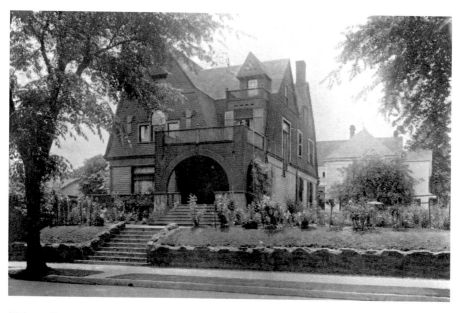

Holman Family House, 1911. *Architectural Heritage Center Library.*

"Rose City." Soon, thousands of rose bushes were planted across Portland. The city has been known as the "Rose City" ever since.

In 1906, Frederick Holman became the general counsel for the newly founded Portland Railway Light and Power Company, a precursor to Portland General Electric. He was also something of a popular historian. In 1907, he authored the book *Dr. John McLoughlin: Father of Oregon*. He served as president of the Oregon Historical Society for twenty years.

Sisters Frances and Kate Holman were schoolteachers. They were also involved in civic organizations like the Oregon Pioneer Association and the Daughters of 1812. George, the youngest child in the family, was an attorney. He and Frederick shared offices from the time George graduated law school in 1889 until the 1920s.

Reportedly designed by architect Edgar Lazarus, the Holman House was quite modern for its time. The steeply pitched gambrel roof, exterior wood shingles and covered front porch with rounded archways were all elements of the Shingle style, developed in part by Maine architect John Calvin Stevens in the 1880s.[89] The beautiful interior woodwork in the house was perhaps some of the finest in the city. Oak paneling lined the walls, along with intricately carved fireplace mantels, columns and built-in cabinetry.

Topping it all off were stained- and leaded-glass windows, likely made by Portland's famous Povey Brothers studio.

Once in the midst of a compact residential neighborhood, by the middle of the twentieth century the Holman House stood on the edge of an expanding downtown. After George Holman, the last surviving sibling, died in 1951, subsequent owners converted the house into a law office. It remained in such use for another sixty years. By the early 2000s, there was an ever-increasing amount of pressure to redevelop properties near downtown in order to add housing density. This, combined with lax historic preservation regulations, meant that the Holman House and others nearby would not survive much longer. Despite the outcry from local preservationists, the Holman House was demolished in October 2016. Much of the interior woodwork was salvaged for eventual resale.

ANCIENT ORDER OF UNITED WORKMEN TEMPLE

Prior to the days of employer-provided health insurance, organizations like the Ancient Order of United Workmen (AOUW) provided medical- and life insurance–type benefits to their members while also serving as fraternal organizations useful for establishing business connections within the community.

First established in Pennsylvania in 1868, the AOUW quickly expanded throughout the United States Its first chapter in Portland opened in 1878. After several years of meeting in a variety of locations, including the still extant New Market Theater building on Southwest First Avenue, in 1887, members began raising money to build a new and permanent home, the first of its kind on the West Coast. In November 1891, AOUW directors finally approved plans for their new temple at Southwest Second Avenue and Taylor Street.[90]

Justus F. Krumbein was architect of the new temple, working with a young draftsman by the name of Lionel Deane. Krumbein and Deane had already worked together on the Perkins Hotel; like the Perkins, the AOUW Temple included elements of the Romanesque Revival architectural style. Rather than adorning the building with the type of cast-iron decoration that had been so popular the previous decade, Krumbein and Deane employed an artful combination of heavy stone at the street level, with brick above. Decoration on the building included carved sandstone rosettes and

medallions on the upper stories, oculus windows, Romanesque arches and pairs and trios of Ionic columns high above street level. Topping off the six-story building was an arcade-style cornice. Taken as a whole, the AOUW Temple was, at the time it was completed, one of the most architecturally unique buildings in the city.

When the dedication ceremony for the AOUW Temple took place on June 21, 1894, hundreds of AOUW members from Oregon and around the country attended. At the time, the AOUW was at its peak in popularity, with reportedly more than 300,000 members nationwide. Unfortunately, the success of the AOUW and the Portland temple was short-lived. In 1904, financial difficulties brought about in part by an increased volume of members' benefit payments forced the AOUW to sell its temple building. The new owners, the German Savings and Loan Society, renamed the temple the Tourny Building after George Tourny, the savings and loan's secretary and vice president. Over the next several decades, the building served a variety of purposes. The Oregon Historical Society called the building home from 1913 to 1917. Upper floors, originally housing AOUW offices, became apartments in the 1920s. The frequently changing uses of

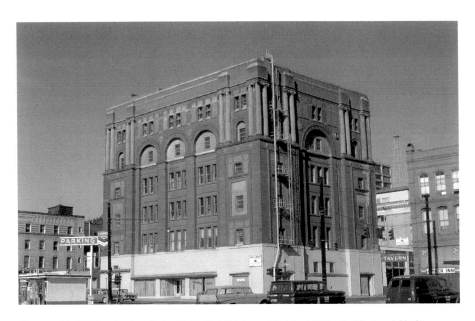

George McMath, *Ancient Order of United Workmen Temple*, 1964. *Architectural Heritage Center Library.*

the building meant that, over time, the interiors lost nearly all traces of the original occupants.

Most of the AOUW Temple was unoccupied by the end of the twentieth century as the building's owners seemed uninterested in adding any real improvements or performing anything beyond basic maintenance. After the last of a series of nightclubs occupying the street-level space closed in 2011, the building was left vacant. In 2015, plans were announced for redevelopment of most of the entire block on which the AOUW Temple stood. Historic preservationists were powerless against the building's owner and Oregon's weak preservation regulations. In the late summer of 2017, the building was demolished.

NOTES

Chapter 1

1. "The New Cathedral," *Oregonian*, October 20, 1879.
2. "A New Courthouse," *Oregonian*, November 22, 1891.
3. "Superb Thespian Temple," *Oregonian*, May 23, 1889.
4. Dan Haneckow, "The Wreck of the Marquam Grand," *Café Unknown*, http://www.cafeunknown.com/2006_10_01_archive.html.
5. Ibid.
6. "Library Building and Ornament to Portland," *Oregonian*, July 3, 1893.
7. Cheryl Gunselman, "Library Association of Portland," *The Oregon Encyclopedia*, https://oregonencyclopedia.org/articles/library_association_of_portland/.
8. "Big Theater to Rise on Old Library Site," *Oregonian*, November 23, 1913.
9. "Building Operations," *Oregonian*, April 16, 1887.
10. "John Nestor, Architect," *Oregonian*, January 22, 1868.

Chapter 2

11. "New East-Side High School to Cost One Hundred Thousand Dollars," *Oregonian*, June 25, 1905.
12. "Criticized by Architects," *Oregonian*, March 15, 1908.
13. "County Hospital Historic Building," *Oregonian*, September 9, 1923.

14. "New Hospital Need Told," *Oregonian*, November 18, 1914.

15. Elaine S. Friedman, "Congregation Beth Israel," *The Oregon Encyclopedia*, https://oregonencyclopedia.org/articles/congregation_beth_israel.

16. "Jewish Synagogue Destroyed by Fire," *Oregonian*, December 30, 1923.

17. Chet Orloff, "Henry Failing, 1834 – 1898." *The Oregon Encyclopedia*, https://oregonencyclopedia.org/articles/failing_henry_1834_1898_.

18. Arthur W. Hawn, "The Henry Failing House," *Oregon Historical Quarterly* 82, no. 4 (1981), 364.

19. Ibid., 367–368.

20. "Elks Dedicate Their Temple," *Oregonian*, February 2, 1906.

21. "Fine Home for Portland Elks," *Oregonian*, January 21, 1906.

22. "Salvage Totals $12,000," *Oregonian*, February 5, 1924.

23. William J. Hawkins and William F. Willingham, *Classic Houses of Portland, Oregon 1850–1950* (Portland, OR: Timber Press, 1999), 147.

24. "City's Progress Dooms Famous Dolph Mansion," *Oregonian*, August 29, 1926.

25. Ibid.

26. William Stokes, letter to the editor, "The High School Repairs," *Oregonian*, August 9, 1895.

27. "Mothers' Classes Scheduled to Open," *Oregonian*, September 21, 1919.

28. "New Type Building of 8 Stories, Plan," Oregonian, January 15, 1922.

29. "Hot Cakes Not in It, Suffrage Sandwiches Sell to Great Avail," *Oregonian*, June 12, 1912.

30. John M. Tess, Richard Ritz and Robert Mawson, *National Register of Historic Places Nomination: Neighbors of Woodcraft Building, Multnomah County, Oregon* (Portland, OR: Heritage Investment Corporation,1995), 15.

31. "City News in Brief," *Oregonian*, March 21, 1892.

Chapter 3

32. Alfred E. Powers and Howard McKinley Corning, eds., *Works Progress Administration, Adult Education Project: History of Education in Portland* (1937), 32.

33. "Harrison School Burned," *Oregonian*, September 7, 1887.

34. "Mr. Hodgson a Winner," *Oregonian*, July 13, 1890.

35. E. Kimbark MacColl, *The Shaping of a City: Business and Politics in Portland, Oregon, 1885–1915* (Portland, OR: Georgian Press, 1976), 88.

36. "$25,000 Contract Let on Building," *Oregonian*, April 28, 1935.

37. Philip Niles, *Beauty of the City, A.E. Doyle, Portland's Architect* (Corvallis: Oregon State University Press, 2008), 156–157.

38. "Corbett Manse, Historic Landmark, Being Razed; House Sturdily Built," *Oregonian*, October 4, 1936.

39. Ancient Order of Hibernians, "AOH History," *Ancient Order of Hibernians*, https://aoh.com/aoh-history.

40. *Oregonian*, March 14, 1891.

41. "Weiner Store Opens Today," *Oregonian*, November 1, 1939.

42. Leland Roth, "Equitable Building," *The Oregon Encyclopedia*, https://oregonencyclopedia.org/articles/equitable_building.

43. William J. Hawkins III, *The Grand Era of Cast-Iron Architecture in Portland* (Portland, OR: Binford & Mort, 1976), 26.

44. "D.P. Thompson Estate Would Donate New Home for Historic City Fountain," *Oregonian*, March 13, 1928.

45. *Oregonian*, July 28, 1893.

46. "A Model Building," *Oregonian*, February 19, 1893.

47. "Reached the Top," *Oregonian*, March 6, 1892.

48. Herbert Lundy, "Vice: Army Battles a Dangerous '5th Column,'" *Oregonian*, June 29, 1941.

49. Advertisement, *Oregonian*, September 21, 1941.

50. "Hill Military School," *Oregonian*, September 12, 1901.

51. William Cornett and Kenneth R. Coleman, "Hill Military Academy," *The Oregon Encyclopedia*, https://oregonencyclopedia.org/articles/hill_military_academy.

52. "Building Protest Before Council," *Oregonian*, June 27, 1943.

53. Hawkins, *The Grand Era of Cast-Iron Architecture in Portland*, 138.

54. *Oregonian*, September 23, 1949.

55. "Fine Home in View," *Oregonian*, November 21, 1909.

Chapter 4

56. "A Lofty Structure," *Oregonian*, October 17, 1891.

57. Harry Stein, "The Oregonian," *The Oregon Encyclopedia*, https://oregonencyclopedia.org/articles/oregonian.

58. Fred M. White, "The Oregonian Century—Story of a Newspaper," *Oregonian*, December 4, 1950.

59. "City Move Seeks Wrecking of Old Oregonian Building," *Oregonian*, January 13, 1950.

60. "Our Improvements," *Oregonian*, January 1, 1885.
61. U.S. Census Bureau, "Schedule No. 1 Population, Multnomah County, Oregon," *Twelfth Census of the United States*, 1900.
62. "Knapp Residence Sold," *Oregonian*, July 28, 1901.
63. Alexander B. Craghead, *Railway Palaces of Portland, Oregon: The Architectural Legacy of Henry Villard* (Charleston, SC: The History Press, 2016), 88.
64. Dan Haneckow, "The Ainsworth Age," *Café Unknown*, http://www.cafeunknown.com/2009/03/ainsworth-age-for-fifty-nine-years.html.
65. Stuart McElderry, "Building a West Coast Ghetto: African American Housing in Portland, 1910–1960," *Pacific Northwest Quarterly* 92, no. 3 (2001): 137.
66. "All Will Resume—The Suspended Banks' Affairs," *Oregonian*, July 30, 1893.
67. "Death of R.S. Perkins," *Oregonian*, April 30, 1902.
68. "A Great Caravansary," *Oregonian*, February 4, 1891.
69. Carl Abbott, *The Great Extravaganza: Portland and the Lewis and Clark Exposition* (Portland: Oregon Historical Society Press, 1981), 46.
70. "Flames Level Historic Forestry Building," *Oregonian*, August 18, 1964.
71. William Toll, "Ethnicity and Stability: The Italians and Jews of South Portland, 1900–1940," *Pacific Historical Review* 54, no. 2 (1985): 169–171.
72. Carl Abbott, *Portland: Planning, Politics, and Growth in a Twentieth-Century City* (Lincoln: University of Nebraska Press, 1983), 210.
73. "Academy's Closing Will Cause Regret," *Oregonian*, March 12, 1916.
74. "City Denies Razing Order," *Oregonian*, March 12, 1965.
75. *Oregonian*, February 19, 1888.
76. Ibid.

Chapter 5

77. E. Kimbark MacColl, *The Growth of a City: Power and Politics in Portland, Oregon, 1915 to 1950* (Portland, OR: Georgian Press, 1979), 488.
78. Sydney Clevenger, "St. Vincent's and the Sisters of Providence: Oregon's First Permanent Hospital," *Oregon Historical Quarterly* 102, no. 2 (2001): 216.
79. Ibid, 219.
80. "Buyers to Convert Princess Hotel into Residence for Single People," *Oregonian*, June 1, 1968.
81. "Open for Inspection," *Oregonian*, February 21, 1912.

82. *Oregonian*, August 29, 1904.

83. Edward H. Teague, "Edgar M. Lazarus, Architect: Life and Legacy." University of Oregon, 2011, http://pages.uoregon.edu/ehteague/lazarus.

84. *Oregonian*, May 23, 1925.

85. Elaine S. Friedman, "Congregation Neveh Shalom," *The Oregon Encyclopedia*, https://oregonencyclopedia.org/articles/congregation_neveh_shalom.

86. *Oregonian*, September 6, 1978.

87. Historic American Buildings Survey, U.S. Department of the Interior, *HABS No. OR-130, Hotel Lenox*, 8.

88. "Gas Plant to Cost 3 Millions [sic] is Plan," *Oregonian*, March 3, 1912.

89. Hawkins and Willingham, *Classic Houses of Portland, Oregon 1850–1950*, 191.

90. "The A.O.U.W. Temple," *Oregonian*, November 21, 1891.

BIBLIOGRAPHY

Books

Abbott, Carl. *The Great Extravaganza: Portland's Lewis and Clark Exposition.* 3d ed. Portland: Oregon Historical Society Press, 2004.

————. *Portland: Planning, Politics, and Growth in a Twentieth Century City.* Lincoln: University of Nebraska Press, 1983.

Blalock, Barney. *Portland's Lost Waterfront: Tall Ships, Steam Mills and Sailors' Boardinghouses.* Charleston, SC: History Press, 2012.

Craghead, Alexander Benjamin. *Railway Palaces of Portland, Oregon: The Architectural Legacy of Henry Villard.* Charleston, SC: History Press, 2016.

Hawkins, William J. III. *The Grand Era of Cast-Iron Architecture in Portland.* Portland, OR: Binford & Mort, 1976.

Hawkins, William J. III, and William F. Willingham. *Classic Houses of Portland, Oregon: 1850–1950.* Portland, OR: Timber Press, 1999.

Labbe, John T. *Fares, Please! Those Portland Trolley Years.* Caldwell, ID: Caxton Printers, 1980.

Lansing, Jewell. *Portland: People, Politics and Power, 1851–2001.* Corvallis: Oregon State University Press, 2005.

Lewis & Dryden Printing Company. *The Oregonian Souvenir, 1850–1892.* Portland, OR: Lewis & Dryden Printing, 1892.

MacColl, E. Kimbark. *The Growth of a City: Power and Politics in Portland, Oregon 1915 to 1950.* Portland, OR: Georgian Press, 1979.

————. *The Shaping of a City: Business and Politics in Portland, Oregon 1885 to 1915.* Portland, OR: Georgian Press, 1976.

MacColl, E. Kimbark with Harry H. Stein. *Merchants, Money, & Power: The Portland Establishment 1843–1913*. Portland, OR: Georgian Press, 1988.

Niles, Philip. *Beauty of the City: A.E. Doyle Portland's Architect*. Corvallis: Oregon State University Press, 2008.

Prince, Tracy J., and Zadie J. Schaffer. *Notable Women of Portland*. Charleston, SC: Arcadia Publishing, 2017.

Ritz, Richard Ellison. *Architects of Oregon: A Biographical Dictionary of Architects Deceased - 19th and 20th Centuries*. Portland, OR: Lair Hill Publishing, 2002.

Snyder, Eugene E. *Early Portland: Stump-Town Triumphant*. Portland, OR: Binford & Mort, 1970.

Thompson, Richard. *Portland's Streetcar Lines*. Charleston, SC: Arcadia Publishing, 2010.

Journal Articles

Clevenger, Sydney. "St. Vincent's and the Sisters of Providence: Oregon's First Permanent Hospital," *Oregon Historical Quarterly* 102, no. 2 (2001): 210–221.

Hawn, Arthur W. "The Henry Failing House," *Oregon Historical Quarterly* 82, no. 4, (1981): 352–368.

McElderry, Stuart. "Building a West Coast Ghetto: African American Housing in Portland, 1910–1960," *Pacific Northwest Quarterly* 92, no. 3 (2001): 137–148.

Toll, William. "Ethnicity and Stability: The Italians and Jews of South Portland, 1900–1940," *Pacific Historical Review* 54, no. 2, (1985): 161–189.

Newspapers and Magazines

Oregonian, 1868–1987.

Oregon Journal, 1904–1907.

West Shore, 1875–1891.

Papers and Reports

Historic American Buildings Survey, U.S. Department of the Interior, *HABS No. OR-130, Hotel Lenox*, 1980.

Powers, Alfred E. and Howard McKinley Corning, Ed. *Works Progress Administration, Adult Education Project: History of Education in Portland*, 1937.

Tess, John M., Richard Ritz and Robert Mawson. *National Register of Historic Places Nomination: Neighbors of Woodcraft Building, Multnomah County, Oregon,"* Portland, OR: Heritage Investment Corporation, 1995.

U.S. Census Bureau, "Schedule No. 1 Population, Multnomah County, Oregon," *Twelfth Census of the United States*, 1900.

Websites

Ancient Order of Hibernians. "AOH History," *Ancient Order of Hibernians.* https://aoh.com/aoh-history.

Cornett, William and Kenneth R. Coleman. "Hill Military Academy." *The Oregon Encyclopedia.* https://oregonencyclopedia.org/articles/hill_military_academy.

Friedman, Elaine S., "Congregation Beth Israel," *The Oregon Encyclopedia*, https://oregonencyclopedia.org/articles/congregation_beth_israel.

————. "Congregation Neveh Shalom." *The Oregon Encyclopedia*, https:// oregonencyclopedia.org/articles/congregation_neveh_shalom.

Gunselman, Cheryl. "Library Association of Portland," *The Oregon Encyclopedia*, https://oregonencyclopedia.org/articles/library_association_of_portland.

Haneckow, Dan. "The Wreck of the Marquam Grand," *Café Unknown*, http://www.cafeunknown.com/2006_10_01_archive.html.

Historic Oregon Newspapers, https://oregonnews.uoregon.edu.

Orloff, Chet. "Henry Failing, 1834 – 1898." *The Oregon Encyclopedia*, https:// oregonencyclopedia.org/articles/failing_henry_1834_1898_.

Roth, Leland. "Equitable Building," *The Oregon Encyclopedia.* https:// oregonencyclopedia.org/articles/equitable_building.

Stein, Harry. "The Oregonian," *The Oregon Encyclopedia*, https:// oregonencyclopedia.org/articles/oregonian/

Teague, Edward H. "Edgar M. Lazarus, Architect: Life and Legacy." University of Oregon, 2011. http://pages.uoregon.edu/ehteague/lazarus.

INDEX

A

Abernethy School 63
Abington Building 58, 107, 108, 109
A. E. Doyle & Associates 62
African Americans 31, 91, 92
Ahavai Sholom Synagogue 38, 123, 124
Ainsworth Bank 89
Ainsworth Block 69, 88, 89, 90
Ainsworth, Captain John C. 88, 89
Ainsworth, George J. 90
Ainsworth National Bank 90
Albina 50, 90, 91, 92, 93
Alder Street 32, 41, 43, 46, 49, 81
Allen, Paul 93
American Power and Light Company 131
Ancient Order of Hibernians 59, 60, 139, 145
Ancient Order of United Workmen 28, 134, 135
Ancient Order of United Workmen Temple 134, 135
Ankeny Street 46, 66
Anti-Saloon League 70
Architectural Heritage Center 11, 72, 159
Arthur Street 99
Ash Street 88

B

Back, Seid 91
Baker, George 22
Baldwin, Lola G. 70
Bank of British Columbia 66
Barbur Boulevard 34, 66
Bean, Ormond 111, 112
Belluschi, Pietro 43, 62, 81
Benevolent and Protective Order of Elks 40
Bennes, John V. 49
Benson Hotel 87

Benton Hall 132
Bethel African Methodist Episcopal
 Church 91, 92
Beth Israel Synagogue 36, 38, 83,
 124
Bishop's House 14
Blight 99
Bohemian Restaurant 117
Bosco-Milligan Foundation 72
Boyd Coffee Company 105
Bradbury, Sallie 50
Breeden, Henry C. 50
Brick Buildings 14, 15, 19, 20, 22,
 25, 32, 33, 38, 40, 53, 56,
 62, 64, 66, 67, 70, 81, 83, 95,
 103, 105, 115, 117, 119, 125,
 134
Broadway 22, 40, 53, 81, 90, 91, 92,
 93, 127
Broadway Bridge 91
Brookman, Herman 121
Buchtel, Chester C. 33, 38, 124
Burnside Street 17
Burton, Elwood M. 18, 46
Bus Depot 59

C

Calvary Presbyterian Church 83
Carson, Joseph 112
Cast-Iron 34, 46, 64, 67, 75, 89, 95,
 104, 105, 107
Catholic Sisters of Mercy 120
Central Eastside Industrial District
 62
Central School 16, 17, 53, 85
chamber of commerce 98
Chamber of Commerce 119

Chamber of Commerce Building
 54, 56, 93, 119
Chapman Square Park 125
Charles and Hedwig Smith House
 34, 35
Charles and Sallie Forbes House 50
City Foundry 107
City Jail 71
City of Portland 25, 66, 70, 83, 88,
 92, 97, 98, 99, 100, 106, 110,
 111, 112, 120, 130
City Park (Washington Park) 50, 93
Civic Auditorium 18
Civic Stadium 101
Classical Revival Style 24, 125, 127
Cleaveland, Henry 39, 42
Clemens, Samuel (as Mark Twain)
 22, 87
Clifton Street 102
Coffey, Robert C. 27
Colonial Revival Style 78
Columbia Street 42, 81, 99, 104,
 105
Columbia Villa 92
Commerce High School 53
Condominiums 118, 119
Congregation Beth Israel 36, 138,
 145
Congregation Neveh Shalom 124
Congress Hotel 35, 87, 121, 123
Cooke's Music School 107
Corbett Building 127, 128, 129,
 130
Corbett, Elliot R 127
Corbett, Emma 58, 59
Corbett, Henry L. 127
Corbett, Henry W. 38, 58, 69, 70,
 86, 103
Cornelius Hotel 49

Cornett, Marshall E. 74
Couch, Captain John H. 14
Couch School 16, 26
Council of Jewish Women 116
Craftsman style 40
Craigdarroch Castle 83
Crosby, Captain Nathaniel 13
Crosby House 13

D

Daggett, Freeman E. 125
da Vinci Arts Middle School 45
Davis Building 109
Davis, H. B. 109
Davis Street 64, 84
Day, Clinton 88
Deady, Judge Matthew 23
Deane, Lionel 134
Dekum Building 46
DeLashmutt, Van B. 67
Dodd Block 75, 95
Dolan Wrecking Company 71
Dolph, Cyrus A. 42, 43, 72
Dolph, Joseph N. 42, 43, 72
downtown plan 88
downtown transit mall 130
Doyle, Albert E. 22, 40, 58, 70, 87, 97

E

Eastern Outfitting Co. 116
Eastlake style 26
East Portland 32, 50, 62
East Portland School Board 62
East Side Central School 32
East Side High School 32, 45

Eighteenth Avenue 84
Eighth Avenue 92
Eighth Avenue (Southeast) 62
Eleventh Avenue 41, 73, 117
Elks Lodge 40, 41
Elks Temple 41
Emil Schacht & Son 78
Episcopal Church of Oregon and
 Washington 24
Equal Suffrage League 116
Equitable Building
 (Commonwealth) 62, 139,
 145
Everett Street 84

F

Failing, Henry 38, 39, 40, 42, 58,
 86, 138, 144, 145
Farrell, Robert S. Jr. 74
Federal Aid Highway Act (1956)
 102
Federal Housing Act of 1949 100
Federal Interstate Highway
 Program 101
Fierens, Father J. T. 14
Fifteenth Avenue 40, 102, 132
Fifth Avenue 36, 38, 42, 45, 48, 53,
 58, 69, 95, 109, 113, 114, 127,
 128, 130
fireproof construction 32, 33, 70,
 81, 121
fires 18, 26, 32, 33, 34, 38, 39, 53,
 56, 62, 64, 70, 74, 76, 77, 80,
 81, 98, 104, 107, 124, 126
First Avenue 23, 30, 34, 46, 60, 65,
 66, 75, 83, 99, 104, 105, 108,
 111, 134, 140, 144

First Evangelical Church 125
First Methodist Episcopal 30
First National Bank 89, 128
First National Bank of Portland 38
First Presbyterian Church 60
Flanders Street 36
Flemish style 103
Fliedner, William 57
floods 13, 64, 65
food carts 117
Foothills Freeway 101
Forbes, Charles M. 45, 50, 51
Forbes, Sallie 51
Forestry Building 97, 98, 140
Fourteenth Avenue 32, 102
Fourth Avenue 13, 18, 20, 25, 54,
 56, 77, 99, 102
Frank, Aaron M. 87
Frank, M. Lloyd 121
Frank's Parkview Inn 126
Fred Meyer 129
freeways 26, 80, 99, 101, 102, 103,
 104, 124
Fremont Bridge 66, 102
French Second Empire style 39, 46, 58
Front Avenue 26, 38, 64, 65, 66, 69,
 75, 77, 95, 99, 105, 111, 112
Front Avenue Improvement Project
 66

G

German Savings and Loan Society
 135
Gilbert Building 95
Girls' Polytechnic School 45
Glass, Graham 51
Glisan Street 26

Goldsmith, Philip 93
Goode Henry W. 51
Goodnough Building 127, 129, 130
Goodnough, Ira E. 127
Gothic Style 28, 45, 105
Grace Episcopal Church 28
Great Depression 32, 46, 52, 60, 66,
 70, 77, 97, 100, 105, 111, 121
Great Light Way 109

H

Hallock, Absalom B. 64
Hallock and McMillan Building 67
Hamilton Building 46, 69
Hancock Street 91
Harbor Drive 66, 99, 112, 113
Harrison, Benjamin 115
Harrison School 16, 138
Harrison Street School 53
Harrison Street (Southeast) 62
Hawkins, Luther L. 90
Hawkins, William J. 90
Hawthorne Bridge 20, 34, 65, 66,
 69, 111
Hayslip, Sydney B. 111
Hazelwood Creamery 116
Hefty, Henry J. 25, 56, 57, 67
Hendricks, Eric W. 49
Henry and Emma Corbett House
 38, 58
Henry Failing House 38, 42, 58,
 138, 144
Hibernian Building 59, 60
Hill, James A. 75
Hill, Joseph W. 73
Hill Military Academy 73, 74, 75,
 139, 145

Hill-Ton 119
Hill, Virginia 119
Hirsch, Josephine 116
Hirsch, Solomon 115, 116
Hobart-Curtis Hotel 119
Hodgson, Isaac Jr. 20, 54, 56, 93, 119, 138
Holladay, Ben 14
Holladay, Esther 14
Holman, Edward 57
Holman Family House 132, 133, 134
Holman, Frances 132, 133
Holman, Frederick V. 132, 133
Holman, George 132, 133, 134
Holman, Kate 132, 133
Holsman, Isidore 48
Holton House 95
Honeyman, John 107
Hooker Street 34
Hoover, Herbert 87
Houghtaling & Dougan 33
housing segregation 92
Hoyt Street 26
Huerne, Prosper Louis-Etienne 14
Humphrey, Hubert H. 123

I

immigrants 31, 59, 69, 91, 99
implosion 130
Industrial Fair Exposition Building 17
Interstate 5 66, 90, 93, 102
Interstate 405 26, 66, 99, 101, 102, 103, 104, 124
Ione Plaza 72

Isom, Mary Frances 24
Italianate Style 19, 20, 58, 72, 95
Italian Renaissance style 127
Italian residents 99

J

Jackson Tower 81, 127
Jacobberger, Joseph 73, 74
Jacob Kamm House 39
Jacobs-Dolph House 72
Jacobs Family Houses 72
Jacobs, Isaac 43, 72
Jacobs, Isaace and Ralph 72, 83
Jacobs, Ralph 72
Jeanne d'Arc 119, 120
Jefferson High School 33
Jefferson Street 30, 39, 42, 119
Jewish residents 99
J.K. Gill Company 48
Jones, George H. 63
Jones, Thomas J. 32, 62, 63
Jorgensen, Edwin D. 125
Jorgensen, Emil C. 125
Jorgensen, Victor H. 125
Joseph and Augusta Dolph House 42
justice center 71, 126

K

Kadderly and Morton 90
Kaiser Corporation 92
Kamm Block 34, 66, 75, 77
Kamm, Jacob 39, 75, 76, 77
Kennedy, Robert F. 123

KGW Radio 81
KGW Television 120
King, Amos and Matilda 77
King, Martha 78, 79
King, Nahum A. 77, 79
King's Hill Historic District 79
Kleeman, Otto 53, 113
Knapp, Burrell and Company 83
Knapp House 83, 84, 85
Knapp, Minnie 84
Knapp, Richard B. 72, 83, 84
Kohn, Charles 70
Krumbein, Christine 91
Krumbein, Justus F. 17, 22, 26, 27, 34, 75, 91, 95, 104, 117, 134
Ku Klux Klan 114

L

Ladd Block 104, 105, 106
Ladd, Eric 85, 115
Ladd & Tilton Bank 23, 28, 64
Ladd, William S. 64, 66, 103, 105
Lair Hill 116
Lair Hill Park 34, 36
Larrabee Avenue 91, 93
Lawrence, Ellis F. 33, 111
Lawrence, Holford, Allyn, and Bean 111
Lazarus, Edgar 70, 123, 133
Leadbetter, Frederick W. 94
Lenox Hotel 78, 125, 126
Levi White House 26, 34
Lewis and Clark Centennial Exposition 18, 87, 97, 98, 125, 132
Lewis and Clark College 121
Lewis and Clark Exposition 140

Liberty Theater 24
Library Association of Portland 23, 24, 137, 145
Lincoln Hall 77
Lincoln High School 33, 45, 77
Lindley, Joseph 85
Lindley, Lucilla 85
Lipman's Department Store 97
Loewenberg, Bertha 94
Loewenberg House 93
Loewenberg, Julius 93, 94, 115
Louis-Dreyfus Grain Elevator 90
Lower Albina 91, 92
Loyalty Building 48

M

MacColl, E. Kimbark 113
Madison Street 64, 69, 125
Madison Street Bridge 32, 67, 69
Main Street 18, 25, 34, 35, 36, 38, 48, 116, 121, 125
Marabba West 120
Market Street 17, 45, 113, 124
Markle, George, Jr. 54
Marquam Bridge 21, 102
Marquam Building 20, 21, 22, 40, 81, 86, 102, 137, 145
Marquam Grand Opera House 20, 87
Marquam Gulch 99
Marquam Hill 21, 35, 36
Marquam, Philip A. 20, 21, 22
Marshall Street 74, 117
Martin, Richard, Jr. 17, 40
Marylhurst University 113
Masonic Building Association 48
Masonic Temple 46, 48
Masons 46, 47, 48, 114

McCarthy, Eugene 123
McCaw & Martin 54, 60, 83
McCaw, William F. 60, 83
McGuire Building 58
McGuire, Frank L. 58, 107
McKay Block 109
McKim, Charles 85
McKim, Mead, and White 85, 86
McMath, George A. 106
McMillen House 90, 92
McMillen, James H. 90
McMillen's Addition 90, 91, 92, 93
McMillen Street 91
Mechanics' Fair Pavilion 17
Meier & Frank 87, 88
Melvin Mark Properties 58
Merchants National Bank 93
Merchants Savings and Trust
 Company 60
Merchants' Trust Building 60
Metropolitan Learning Center 26
Meyer, Fred 129
Mill Street 72, 113
Milwain, Alexander M. 17
Moda Center 90
Monroe High School 45
Montgomery Park 97
Montgomery Street 72, 73, 103
Morey, Clara 84
Morey, Parker F. 84
Morrison Street 16, 20, 21, 32, 40,
 43, 48, 50, 66, 86, 111, 127, 130
Mother Joseph 117
Moy Building 121
Mulkey, Augusta 42, 43
Multnomah Athletic Club 18
Multnomah County 18, 19, 20, 24,
 34, 35, 36, 46, 56, 119, 126,
 138, 140, 145

Multnomah County Central
 Library 24
Multnomah County Circuit Court
 124
Multnomah County Courthouse
 18, 20, 46
Multnomah County Hospital 35,
 36
Multnomah Hotel 87

N

Naito Parkway 64, 67, 75
National Register of Historic Places
 50, 59, 138, 145
Neighborhood House 116
Neighbors of Woodcraft 49, 50,
 138, 145
Nestor, John 28, 137
Neustadter Building 69
Neveh Zedek 124
New Market Theater 134
New York Life Insurance Company
 54, 56
Nineteenth Avenue 17
Ninth Avenue 115
Northern Pacific Railroad 70, 76,
 85
Northern Pacific Terminal
 Company 16
North Pacific Sanatorium 27
North Park Blocks 124
Northrup, Henry H. 119
Northrup Street 117
Northwestern Bank Building 22
NW Natural 131, 132

O

Oak Street 36, 67, 69, 71, 88, 123
Odd Fellows 47
Ohio Hotel 69
Orbanco Building 123
Orbanco Building (Congress
 Center) 123
Oregon City Woolen Mills 72, 128
Oregon Episcopal School 24, 26
Oregon Furniture Manufacturing
 Company 95
Oregon Health and Science
 University 11, 21
Oregon Historical Society 11, 94,
 97, 133, 135, 140, 143
Oregon Home Designers 107
Oregonian newspaper 81
Oregonian Tower 70, 81, 83
Oregon Journal 46, 112, 127, 144
Oregon National Bank 67
Oregon Pioneer Association 133
Oregon Railroad & Navigation
 Company 70
Oregon Socialist Labor Party 70
Oregon State Bar 132
Oregon State Highway Division
 101
Oregon State Hospital 38, 124
Oregon State Penitentiary 94
Oregon State University 132
Oregon Steam Navigation
 Company 75, 88
Oriental Exhibits Building 125
Otis Elevator Company 107

P

Pacific Building 58, 59
Pacific International Livestock
 Association 18
Panic of 1873 14
Panic of 1893 55, 60, 67, 93, 95
Park Avenue 48, 49, 50, 72, 73, 102,
 123, 124
Parker, Jamieson 103
parking garages 71, 83, 87, 90
parking lots 10, 17, 30, 38, 50, 56,
 70, 71, 77, 85, 88, 90, 93, 109,
 115, 117, 120
Park Place 25, 50, 93
Park Vista Apartments 51
Pearl District 18, 43
Perkins Hotel 95, 96, 134
Perkins, Richard S. 95
Peterson, Fred L. 100
Pierce, Walter M. 114
Pine Street 69, 71, 75, 88, 123
Pioneer Courthouse 10, 16, 17, 58,
 59, 88, 130
Pioneer Courthouse Square 10, 17,
 88, 130
Pioneer Place shopping mall 45,
 130
Piper & Burton 46
Piper, William W. 18, 46
Pittock, Henry L. 81
police headquarters 71
Portland Academy 26, 102, 103,
 104
Portland Art Museum 48, 69, 72,
 85
Portland Business College 127, 130
Portland Cathedral 14

Portland Chamber of Commerce 98

Portland Chess Club 70

Portland City Council 50, 57, 66, 75, 106, 111, 125

Portland City Hall 19, 25, 43, 50, 56, 57, 112

Portland Creative Theater Company 116

Portland Development Commission 100, 101, 105, 126, 130

Portland Expo Center 18

Portland Farmers Market 113

Portland Gas and Coke Co. 131, 132

Portland Gas and Coke Co. Building 130, 132

Portland Gas Company 131

Portland General Electric 51, 64, 84, 133

Portland High School 43, 45, 46, 113

Portland High School of Commerce 53

Portland Historical Landmarks Commission 106, 125, 130

Portland Hotel 10, 16, 20, 24, 25, 69, 81, 83, 85, 86, 87, 88, 119

Portland Library 23, 24, 69

Portland Planning Commission 111

Portland Public Market 113

Portland Public Schools 77, 93

Portland Railway Light and Power Company 133

Portland Realty Board 92

Portland Rose Festival 97

Portland Rose Society 132

Portland Savings and Loan Association 96

Portland School Board 32, 63

Portland School District 16, 28, 32, 43, 53, 63

Portland State College. *See* Portland State University

Portland State University 53, 77, 120, 125, 159

Portland Towers 79

Portland Trailblazers 93

Portland Transit Mall 123

Povey Brothers 134

Providence Park 77, 101

public housing 92

Public Market 66, 110, 111, 112, 113

Public Service Building 40

Pythian Building 48

Q

Queen Anne style 25, 42, 57

R

R. B. Pamplin Incorporated 109

Reconstruction Finance Corporation 111

Red Cross 116

Reed, Amanda 107

Reed College 103, 107

Reed, John 103

Reed, Simeon 107

Reid Brothers 81

reinforced concrete 121

Riverplace 34

Rocky Butte 75

Roman Catholic Church of Oregon 27

Romanesque style 20, 24, 25, 46,
 56, 60, 62, 67, 81, 83, 86, 93,
 95, 117, 119, 127, 134, 135
Roosevelt, Theodore 87
Rose City 133
Rose Garden Arena 90, 93
Rose Quarter 90
Russell Street 91

S

Salmon Street 18, 38, 50, 77, 78,
 116
sanatoriums 35
sandstone 24, 32, 70, 81, 115, 130,
 134
San Francisco 14, 36, 39, 42, 81, 88
Schacht, Emil 78, 125
Schnabel, Charles J. 35, 121
Scott, Harvey W. 81
Scottish Rite Temple 40
Seawall 64, 65, 66
Second Avenue 28, 34, 46, 62, 65,
 71, 121, 134
Security Savings and Trust
 Company 128
segregation 31, 92
Selling, Ben 115
Selling-Hirsch Building 115, 116, 117
Seventh Avenue (Southeast) 62
Seventh (Broadway) 16, 20, 23, 40,
 50, 109
Shaarie Torah 102
Shattuck, Judge Erasmus D. 53
Shattuck School 53
Shemanski, Joseph 116
Shingle style 133
Sisters of Providence 117, 140, 144

Sisters of the Holy Names of Jesus
 and Mary 113, 114
Sixteenth Avenue 102
Sixth Avenue 14, 16, 20, 21, 28, 35,
 38, 40, 42, 53, 58, 60, 81, 83,
 88, 90, 109, 121, 123, 127,
 130
Slow Burning Buildings 70
Smith, Alfred 121
Smith, Arthur L. 107
Smith Brothers and Watson Iron
 Works Company 34, 121
Smith, Charles E. 34, 121
Smith, Hedwig 34, 35, 121
Snell, Governor Earl 74
South Auditorium Urban Renewal
 Area 99, 100, 102, 114
South Park Blocks 31, 43, 45, 72,
 77, 83, 94, 116
South Portland 35, 99, 100, 102,
 140, 144
Spanish Renaissance style 97
Spokane, Portland & Seattle
 Railroad 56
Stadium Freeway 101, 102
Stanford University 88
Stark Street 14, 23, 24, 32, 40, 48,
 54, 60, 62, 64, 90, 105, 107,
 127, 128
State of Oregon 101, 104
St. Clair Avenue 25
Steel Bridge 65, 90
Steinbach, Adolph B. 119
Stephens, James B. 62
Stephens School 62, 63
Stephens Street (Southeast) 62
Stevens, John Calvin 133
St. Helens Hall 24, 25, 26, 50, 56,
 102, 104, 113

St. Helens Road 130
St. Johns Bridge 130
St. Mary's Academy 113, 114, 115
St. Mary's Catholic Parish 85
Stokes, William 43, 45, 50, 70, 127,
 138
Store Properties Incorporated 81
St. Patrick's Cathedral 113
St. Patrick's Catholic Church 53
Streamline Moderne style 57, 62,
 112
streetcars 14, 77, 99
St. Vincent de Paul Society 117
St. Vincent's Hospital 117, 118
Sumida Family 69
Swetland, Lot Q. 95

T

Taylor Street 28, 30, 31, 38, 49, 50,
 58, 95, 132, 134
Taylor Street Methodist Church 28
Tenth Avenue 48, 50, 57, 115, 116
terra-cotta 20, 22, 32, 81, 83, 121,
 123, 125
The Hill 119
The Old Church 83
The Princess 120
Third Avenue 14, 15, 17, 28, 30, 46,
 54, 65, 69, 71, 84, 88, 95, 107,
 108, 109, 125
Thirteenth Avenue 103, 124
Three World Trade Center 34
Thunderbird Motel 93
Tilton, Charles E. 23, 28, 64, 105
Tobey, Willard F. 49
Tom McCall Waterfront Park 64,
 66, 113

Tourny Building 135
Tourny, George 135
Twelfth Avenue 28, 32, 36, 38, 60,
 117, 119
Twentieth Avenue 17, 26, 39, 62
Twenty-Fifth Avenue 74
Twenty-First Avenue 26
Twenty-Fourth Avenue 117

U

Union Banking Company 60
Union Bank of California 24
Union Station 91
University of Oregon 83
University of Oregon Medical
 School 35
University of Oregon's School of
 Architecture and Allied Arts
 33
urban renewal 80, 92, 99, 100, 101,
 102, 105, 114
U.S. Bank 76, 90
U.S. Custom House 123
U.S. National Bank 41, 76, 90
U.S. Navy 112
U.S. Supreme Court 114
U.S. Weather Bureau 75

V

Van Duyn's 130
Vanport 92
Veterans Memorial Coliseum 90,
 92, 93
Villard Hall 83
Villard, Henry 83, 85, 86, 140, 143

Vine Street 66
Vista Avenue 25, 50
Vista House 123
Vue Apartments 72

W

Washington Building 56, 57
Washington High School 32, 33
Washington Street 13, 46, 56, 60,
 62, 64, 84, 95, 107, 115, 116
Weiner, Joe 60, 62
Wells Fargo Building 127
Wentz, Henry 70
Westover Road 117, 118
Wheeler Avenue 91, 93
Wheeler, Edward C. 50
Whidden & Lewis 23, 24, 54, 97,
 103, 127
Whidden, William M. 24, 85, 86,
 127
White, Frederick Manson 70
White, Levi 26, 27, 28, 34
White, Minor 11, 72
Wholesale District 65
Willamette River 9, 13, 21, 28, 62,
 64, 77, 88, 90, 102, 131
Williams, David L. 36, 60, 107, 121
Williams, Franklin 36, 60, 107
Williams, Warren H. 17, 36, 58, 72,
 83, 107, 121
Williams & Williams 60
Wilson, John 24
Wilson, Richard 84
Wilson, Woodrow 87
Wise, Rabbi Stephen S. 36, 38
Witch Hazel Building 67, 68, 69

Witch Hazel Farm 67
woman suffrage 36, 49
Women of Woodcraft 48, 49
Women of Woodcraft Lodge 48
Women's Protective Division 70
Wood, Colonel James M. 22
Woodmen of the World 48, 116
Woods Street 34
Worcester Block 69, 70, 71
Works Progress Administration 63,
 66, 138, 145
World War I 31, 41, 65, 109, 119
World War II 46, 69, 72, 79, 87, 92,
 97, 100, 105, 112, 116

Y

Yamhill Street 13, 16, 45, 48, 58,
 111, 121, 127
Yeon Building 81

ABOUT THE AUTHOR

Val C. Ballestrem is a public historian and for the past decade has served as education manager for the Bosco-Milligan Foundation's Architectural Heritage Center in Portland, Oregon. A lifelong resident of the Portland area, he has a master's degree in western U.S. history and public history from Portland State University. He has previously published several entries in *The Oregon Encyclopedia*.

Visit us at
www.historypress.com